The Design of Everyday Life

Cultures of Consumption Series

Series Editor: Frank Trentmann

ISSN 1744-5876

Previously Published

The Making of the Consumer
Knowledge, Power and Identity in the Modern World
Edited by Frank Trentmann

Consuming Cultures, Global Perspectives
Historical Trajectories, Transnational Exchanges
Edited by John Brewer and Frank Trentmann

Fashion's World Cities
Edited by Christopher Breward and David Gilbert

The Khat Controversy
Stimulating the Debate on Drugs
David Anderson, Susan Beckerleg, Degol Hailu, Axel Klein

Forthcoming Titles

Food and Globalization
Consumption, Markets and Politics in the Modern World
Edited by Alexander Nützenadel and Frank Trentmann

Governing Consumption
New Spaces of Consumer Politics
Clive Barnett, Nick Clarke, Paul Cloke and Alice Malpass

Alternative Food Networks
Reconnecting Producers, Consumers and Food?
Moya Kneafsey, Lewis Holloway, Laura Venn, Rosie Cox, Elizabeth Dowler
and Helena Tuomainen

The Design of Everyday Life

ELIZABETH SHOVE,
MATTHEW WATSON,
MARTIN HAND
and
JACK INGRAM

⊕BERG

Oxford • New York

First published in 2007 by
Berg
Editorial offices:
1st Floor, Angel Court, 81 St Clements Street, Oxford, OX4 1AW , UK
175 Fifth Avenue, New York, NY 10010, USA

Berg is the imprint of Oxford International Publishers Ltd.

This book has been produced with the support of the Economic and Social Research
Council and the Arts and Humanities Research Council

Library of Congress Cataloguing-in-Publication Data
The design of everyday life / Elizabeth Shove ... [et al.].
 p. cm. — (Cultures of consumption series)
 Includes bibliographical references and index.
 ISBN-13: 978-1-84520-682-6 (cloth)
 ISBN-10: 1-84520-682-7 (cloth)
 ISBN-13: 978-1-84520-683-3 (pbk.)
 ISBN-10: 1-84520-683-5 (pbk.)
 1. Material culture. 2. House furnishings industry and trade. 3. Household
supplies. 4. Home economics. 5. Consumption (Economics)—Social
aspects. 6. Consumers—Psychology. I. Shove, Elizabeth, 1959-
 GN406.D47 2007
 645—dc22

 2007033748

British Library Cataloguing-in-Publication Data
A catalogue record for this book is available from the British Library.

ISBN 978 1 84520 682 6 (Cloth)
ISBN 978 1 84520 683 3 (Paper)

Typeset by JS Typesetting, Porthcawl, Mid Glamorgan
Printed in the United Kingdom by Biddles Ltd, King's Lynn

www.bergpublishers.com

Contents

List of Figures

Acknowledgements

This book would not exist had it not been for a research project entitled 'Designing and consuming: objects, practices and processes' (Award no. RES-154-25-0011). Elizabeth Shove, Matt Watson, Jack Ingram and Louise Annable all had a hand in this project (further details can be found at www.lancs.ac.uk/fss/sociology/staff/shove/dnc). The project itself would not have existed without Economic and Social Research Council and Arts and Humanities Research Council support for the Cultures of Consumption programme.

Chapter 2 makes use of work undertaken as part of another research project, 'Sustainable Domestic Technologies: Changing practice, technology and convention' (Award no. RES-332-25-007), also funded by the Economic and Social Research Council as part of the Sustainable Technologies programme. This was a project in which Dale Southerton, Martin Hand, Elizabeth Shove, Alan Warde and Helen Watkins were all involved.

We would like to thank everyone who has contributed to these two projects whether as respondents and interviewees, as participants and commentators in seminars, workshops and conferences, or as funders, readers and critics of our work. From amongst this crowd the Cultures of Consumption programme director, Frank Trentmann, has been a great support and great fun to work with as well. Beyond these projects and programmes, many of the ideas represented here have been shaped by conversations with Mika Pantzar, Alan Warde and Harvey Molotch.

Beyond the immediate business of researching, thinking and writing, but never that far from it either, we acknowledge the vital contribution of the many other practices and people that have been, and continue to be, important in the design of our own everyday lives.

CHAPTER I

The Design of Everyday Life

Figure I Wallpaper

Ordinary objects are extraordinarily important in sustaining and transforming the details and the design of everyday life. For reasons that have to do with historic and contemporary divisions of intellectual labour, analysis of the hardware of consumer culture and its role in the reproduction of social practice repeatedly falls between the cracks of disciplinary inquiry. This book seeks to recover some of that missing territory and bring the materiality of practice firmly into view.

The normally invisible role of material objects and their significance for the accomplishment of daily routine is momentarily evident when technological innovations provoke or enable changes in how and by whom tasks are defined and accomplished, and in how people organize their time. Domestic appliances like dishwashers, microwaves and fridges have arguably redesigned the shape and meaning of the kitchen, and reconfigured the ordering and organization of domestic routines. Likewise, digital cameras have made a difference to amateur photography, extending the range of photogenic situations and the contexts in which digital images are shared and viewed. These tangible instances of material effects are the more obvious expression of the taken-for-granted relation between daily life and the objects that make it possible.

The observation that things are bought or acquired because they allow people to accomplish valued social practices is not in itself a terribly radical insight. Nor are we the first to suggest that the materials of everyday life warrant theoretical attention within the social sciences and beyond. In his article 'Where are the Missing Masses? A Sociology of a Few Mundane Artifacts' (1992), Bruno Latour argues that social interactions, power structures, institutions and organizational systems are routinely analysed without reference to the volumes of stuff involved. While this is probably true of 'mainstream' sociology, goods and artefacts have a central role in other traditions like those of material culture, archaeology, anthropology, and studies of science, technology and consumption. Anthropologists have had much to say about the social lives of things; people writing about the emergence of consumer society have commented on the commodities involved and, moving fields again, product designers and design academics take relations between products and people to be of defining significance for the nature of their work. Given the vast amount of scholarship represented

by these few sentences, it is perhaps odd to suggest there is need for further theorization of the role of stuff in everyday life.

On the other hand, each of these approaches has a history and a trajectory of its own. There are certain areas of convergence but in highlighting some themes and leaving others in the shadow, these different strands of enquiry have, individually and in combination, resulted in persistent pockets of inattention. Whether a consequence of how the intellectual space of social science was carved out and separated from the physical sciences in the nineteenth century, or because mundane items like kitchen tables and plastic washing-up bowls have failed to capture academic interest, material aspects of social reproduction and change have yet to receive the attention they deserve. In response, the purpose of this book is to show how things are implicated in the development, persistence and disappearance of patterns and practices of everyday life.

This is a tall order and to make any headway at all we home in on a handful of grey areas that lie between established positions and perspectives. The chapters that follow consequently circle around a number of interrelated questions: how to go beyond the study of things as carriers of semiotic meaning? How to think about the agency not only of individual artefacts but of interrelated complexes of stuff? How might we conceptualize the materials of material culture and how do objects and practices co-evolve? In the rest of this introductory section we outline the theoretical 'holes' to which these questions relate and in the process give the reader a sense of the disciplinary approaches on which we draw and between which we bridge.

THINKING ABOUT THINGS

We begin this brief discussion of the social scientific treatment of objects and everyday life with reference to the sociology of consumption. The antecedents of the sociology of consumption certainly did not place material goods at the centre of their enquiry. Through most of the twentieth century, consumption had no distinct identity as a subject of academic interest in its own right, instead figuring as a relatively incidental part of more encompassing analyses of processes and relations of capitalist society and

their consequences for social differentiation and inequality (Veblen 1912 [1899]). In taking the topic seriously, key figures like Bourdieu (1984) and Castells (1977[1972]) stimulated more concerted investigation, helping to create an emerging field that was quickly colonized and populated in ways that reflected and contributed to the ascendancy of cultural approaches in the social sciences. As sociological interest in consumption began to coalesce into an identifiable sub-discipline, and as it began to do so around essentially cultural concerns, so things began to attract attention in their own right. Consumer goods have since been subject to techniques of ethnographic and of literary and semiotic analysis in an effort to understand and analyse the aesthetic, symbolic and experiential dimensions of consumer culture (see Lury (1996) for a survey of such work).

Sociological studies of consumption have continued to develop and diversify over the last few decades. Yet interest in the stuff involved is still largely framed by problems and priorities established in the wake of the linguistic turn and subsequent postmodern approaches. Material objects consequently feature as semiotic intermediaries, carrying meanings and resources for the construction of individual or collective identities (McCracken 1988; Featherstone 1990). With this as the dominant frame of reference, the possibility that such items are also useful, or perhaps even have agency, in enabling and shaping action fades from view. This constitutes a blind spot in which we are particularly interested, and a point of connection with related debates in anthropology.

There is no doubt that social lives have things, that things have social lives, and that anthropologists are interested in both. This is a discipline in which significant agenda-setting work has focused on the ways in which goods move through different systems of ownership, commodification and exchange (Appadurai 1986a), on the identities invested in valued possessions (Csikszentmihalyi and Rochberg-Halton 1981), and on how familiar artefacts and surroundings provide the sense and experience of structure and order. Interests of this sort have been framed and fuelled by efforts to understand the symbolic significance of the gift, and the importance of ritual objects and notions of sacrifice in reproducing cultures, belief systems, and concepts of status and kinship (Mauss 1950 [1990]). While this is a literature in which things play an active part, and while Mauss and others

treat objects as carriers of human agency as well as meaning, the nature of material 'action' is again limited. As with cultural studies, things are rarely treated as matters of substance or as requisite equipment implicated in the design and conduct of daily life.

This partial representation is repeated in the study of material culture, a field that has a complicated ancestry the roots of which wind between the disciplines of anthropology and archaeology. Again it is unfair to generalize too far. The world of the everyday is important, especially for contemporary anthropologists of material culture, as is evident in Daniel Miller's (2001) edited book *Home Possessions*. The articles in this collection look, from different angles, at how people assemble and relate to the things with which they surround themselves at home. In these accounts, and especially in Miller's own contribution, objects have a kind of agency in that they embody and reveal aspects of family life. Put the other way around, the ordering and organizing of possessions can be analyzed as an expression of gender, age, identity and power. In keeping with this convention Attfield (2000) describes how objects are selected and assembled to form personally meaningful configurations of living-room furniture. Alison Clarke (2001) takes a similar approach, using a handful of case studies to describe the aspirations and ideals embodied in three home-decorating projects. In Clarke's analysis, the making over of the home is above all a process of reconciling who people are (where they actually live, what furniture they own, etc.) with an image of who and what they would like to be. She writes as follows: 'The house objectifies the vision the occupants have of themselves in the eyes of others and as such it becomes an entity and process to live up to, give time to, show off to' (Clarke 2001: 42). This is an account of consumer engagement in home improvement (known in the UK as 'do-it-yourself' or DIY) that is free from mess and disruption, and from which tools, techniques and craft skills have simply disappeared. It is about identities and end results, not about physical involvement in the tasks and projects of doing 'it' yourself.

These examples are indicative and representative of how the agency of objects is framed in studies of consumption and culture. There are exceptions, notably Molotch's (2003) analysis of what he refers to as the 'stuff system', by which he means both the relations between things, and the commercial and professional systems that have a bearing on the design

of what gets made. But in sociology, as in anthropology, the common tendency is to privilege the semiotic over the material and to analyse the hardware of consumption with reference to the circulation of meaning and the reproduction of interpersonal relations.

Somewhat different approaches are evident in archaeology. Archaeologists have little option but to be interested in the objects of everyday life, for this is often the only evidence they have to work with. This, then, is a discipline in which things matter, sometimes to excess. Childe, writing in the 1930s, criticized archaeologists for being 'more interested in artefacts than in their makers', and for viewing them as 'dead fossils rather than as expressions of living societies' (Trigger 1989: 173). The approach Childe criticizes is in keeping with a mentality of collecting, and with the project of acquiring, organizing and sorting objects with a view to classifying and distilling super-categories like those of 'material culture' (Buchli 2002). There is more to archaeology than this would suggest, but it is nonetheless the case that archaeological finds have been analysed and interpreted with reference to characteristically grand questions about the origins of human history, the formation of ethnic and 'national' cultures and processes of technological diffusion. Again, there are well established counter-currents, Childe (1939) being one amongst others who have sought to relate the practical uses of artefacts and material innovations to economic and political context (Trigger 1989). Yet the point remains, material objects are routinely studied as traces of social relations and macro-social trends in technology, economics or political structure.

Although relatively marginalized within the disciplines referred to above, questions about how objects enable and shape the practices of daily life are central themes in the field of science and technology studies. Elaborating on this point, Bruno Latour goes so far as to claim that:

> The great import of technology studies to the social sciences is to have shown, for instance, how many features of the former society, durability, expansion, scale, mobility, were actually due to the capacity of artefacts to construct, literally and not metaphorically, social order... They are not 'reflecting' it, as if the 'reflected' society existed somewhere else and was made of some other stuff. They are in large part the stuff out of which socialness is made. (Latour 2000: 113)

Latour notices that things, by which he means technologies, infrastructures and artefacts, 'script' future users, affecting movement and behaviour, and sometimes also configuring goals and aspirations. As his analysis of the deliberately bulky hotel key fob makes clear, human agency can be delegated to what he terms non-human actors. The oversized key fob speaks on behalf of the hotel keeper: it says, by means of its design, 'don't put me in your pocket by accident', 'don't take me away' (Latour 1991). In this account, things (the key fob) make social relations (between client and hotel keeper) durable in ways which go beyond those described by Appadurai (1986a) or by Douglas and Isherwood (1996). The point here is that relations between people can be inscribed and hardwired into the design of material artefacts. As such, it is misleading to think of things as infinitely flexible carriers of ascribed meaning.

In building on concepts of inscription and delegation, studies of science and technology provide a distinctive vocabulary with which to think about agency as an outcome of the relation between artefacts and the humans with whom they interact. The notion of the human-nonhuman hybrid (Latour 1993) was one of a number of terms (see also 'cyborg' (Haraway 1991); 'collectif' (Callon and Law 1997); 'co-agent' (Michael 2000)) added to this repertoire during the 1990s.

To illustrate this concept at its most basic, we might consider the combination of a person and a stick. With stick in hand, the person is transformed into a 'new' hybrid entity – part stick, part human – that can do more than a person or a stick alone. With a lever and a place to stand, much can be achieved. A stick does not have the agency to lever or to hit in and of itself; to do so it needs something – most likely a human – to wield it with force and purpose. Even so, recognizing the relational agency of the stick-person hybrid breaks the convention of supposing that agency is a uniquely human quality: after all, people without sticks are generally less effective at levering or hitting than those who are so equipped.

The simple but radical move of arguing that agency is distributed in, and emergent from, interactions between humans and nonhumans opens the way for new lines of enquiry regarding the role of artefacts in social life. As histories of domestic technology show only too well, automatic washing machines and freezers have changed what it means to keep house and what

skills are required (Cowan 1983). These appliances have been instrumental in shifting the distribution and delegation of roles and functions between human and non-human actors and in redefining the meaning of good and even adequate performance (Shove 2003). One result is that previously important forms of human competence, like the ability to starch well or to mangle correctly, are no longer valued attributes.

By implication, innovations in the world of goods are matched and enabled by parallel processes of learning, delegating and enlisting through which relations between actual and future users and things are realigned. Writers like Kemp, Schot and Hoogma (1998) consequently characterize innovation as a process in which requisite networks of production, consumption and competence stabilize. There are different ways of accounting for this process of embedding. One is to suggest that objects 'configure' their users (Woolgar 1991) and lock them into certain postures, positions and practices. By implication some things have a stabilizing force of their own. Others, including Silverstone, Hirsch and Morley (1992), describe the ways in which devices like video machines, televisions and computers are appropriated into already established patterns of domestic order. In this case, the emphasis is on the extent to which products are assembled and used in ways that reproduce existing habits, routines and moral economies of family life. The central theme here is that new technologies are transformed (in effect), and stabilized by the contexts and situations in which they are adopted.

One problem with both these accounts is that even when technologies appear stable, when their design is 'fixed', their social significance and their relational role in practice is always on the move (Bijker 1992; Shove and Southerton 2000). This suggests that moments of socio-technical closure or in Silverstone's terms, domestication, are illusionary in that objects continue to evolve as they are integrated into always fluid environments of consumption, practice and meaning. In following the semiotic but also practical trajectories of things like the telephone and the car, Mika Pantzar (2003) argues that the dynamics of appropriation never end and that the (re)attribution of meaning is part of a continuous process of normalization, and is as such not restricted to the first moments of innovation.

While science and technology studies attends to interaction between things and people, it does so in ways that are marked and limited by its

own theoretical preoccupations. As indicated above, concepts of scripting, configuration and domestication are routinely deployed with reference to the relation between specific items – the video, the door closer or the stick – and individual users. In this book we move the study of technology and consumption forward by thinking more explicitly about the dynamic relation between complexes of material artefacts, conventions and competences, and hence about the ongoing and characteristically emergent dynamics of everyday practice. This opens the way for a more systematic discussion of the cumulative and collective consequences of domestication and configuration, and for an analysis of how collections of artefacts co-evolve.

Though we are primarily interested in addressing gaps in academic debate, we also take note of working theories of material culture as reproduced by industrial product designers and their clients. As Molotch notices, designers' backgrounds and professional identities have a bearing on what 'stuff ends up being' (2003: 23) and an influence that is itself located in an 'ecological web of institutions, inducements, and impediments' (2003: 23). More specifically, designers are frequently hired to embed tangible but in other respects mysteriously elusive qualities and emotional values into the products on which they work. The immediate pressures and commercial challenges of production and marketing are such that philosophical debate about the role of things in daily life is limited. In this context it is no wonder that established fields like ergonomics are characteristically pragmatic, or that they are organized and oriented around seemingly self-evident problems of making sure the form and function of physical objects fits the needs and situational requirements of those who are to use them. Newer sub-disciplines including semiotics and product semantics have been similarly appropriated and used to inform commercially important decisions about matters of appearance, iconography and visual appeal. In all of this, the dominant logic of design and marketing is to meet what are generally taken to be pre-existing needs. For clients and for designers alike, careful understanding of consumer needs – whether based on rigorous user research or the designer's own intuition – is crucial in defining design opportunities and in determining how these challenges are met.

Whilst the ambition of meeting need has helped sustain the status and identity of the design profession as a whole, it embodies and reproduces

an essentialist view of demand and value that is at odds with the more constructivist approaches of much contemporary social science. Ironically, designers' efforts to understand the user have been framed in such a way that they obscure the crucial point that rather than simply meeting needs, artefacts are actively implicated in creating new practices and with them new patterns of demand. In addressing this gap and in defining the potential for new forms of practice-oriented product design, we consider the practical implications of viewing users and consumers as designers in their own right.

GAPS, CRACKS AND QUESTIONS

This book has two related ambitions. One is to fill some of the gaps and cracks that lie between the tracks of disciplinary development in sociology, science and technology studies, design research and studies of material culture. The other is to do so by pulling threads of different disciplinary approaches together in new combinations. This is not in the hope of producing some sort of totalizing theoretical convergence. Rather, it is with the more modest goal of identifying resources with which to develop a suitably materialized account of the emergence, reproduction and transformation of social practice. Before going further, we take stock of the challenges and orphaned questions identified this far.

First we ask, how are things appropriated and used and how do they make particular social and practical arrangements possible? In addressing this question we build upon debates set in train by recognition of the fact that the bulk of consumption is embedded in relatively inconspicuous routines occasioned by the characteristically mundane socio-technical systems of everyday life. This has inspired what is becoming a distinctive agenda and a significantly different way of analysing and interpreting the cultural dimensions of ordinary consumption (Gronow and Warde 2001). Rather than investigating actions and contexts in which meanings are materialized – for example, in shopping or the self-conscious construction of identity through the purchase and display of consumer goods (Lury 1996; Miller 1998b) – those who write about ordinary consumption have started to focus on things in use. We contribute to this trend.

Second, we counter a tendency, common across design research, science and technology studies and in studies of material culture, to focus on the development and uses of individual artefacts. This emphasis is sometimes a matter of methodology. For example, Wiebe Bijker (1997) studies the history of the bicycle as a means of describing the web of social and technical relations at stake in making bicycles as we know them today. Even so, the dominant pattern is one in which it is the relation between specific artefacts and the social that takes centre stage. If we are to study the stuff of everyday life, we need to pay equal attention to the ways in which artefacts relate to each other and to the part humans and non-humans play in configuring variously stable material taxonomies and variously durable systems of objects.

Third, and again in contrast to much existing work, we are committed to analyzing and understanding the ongoing dynamics of everyday life. This is again a matter of emphasis: we deal with processes of routinization and normalization, but without supposing that these necessarily result in stabilization or closure. Instead we write about emergent projects, about how complexes of consumer goods are integrated in practice, and about what this means for the reproduction and decay of what people do.

Finally, we investigate different ways of understanding value, need and utility, adopting this as a method of revealing tacit and explicit understandings of the role of things in daily life.

In defining and framing these as relatively or significantly missing debates, and in stringing various strands of enquiry together around them, we make use of one further theoretical resource. We contend that theories of practice provide a useful and generative framework with which to integrate, or at least move between, the perspectives outlined above. In making this suggestion, we build on Warde's (2005) contention that consumption should be seen as a consequence of practice and that almost all practices entail consumption. In the context of the present discussion, the more important point is that when applied to matters of consumption, theories of practice require an analysis that goes beyond the realm of symbolic communication, and beyond the actions of seemingly autonomous individuals. This far, artefacts are largely missing from practice-theoretical accounts but in writing this book, one ambition is to combine insights from science studies, and especially Latour,

with those of Giddens (1984) and others who take practices to be the fundamental unit of social analysis.

THE STUFF OF SOCIAL PRACTICE

Theories of practice have a long and fractured intellectual history. Never entirely in the mainstream of social scientific thought and rarely completely absent from it either, there has nonetheless been a definite revival of interest in the last few years. Reckwitz (2002) identifies significant contributions from Bourdieu, Foucault, Giddens, Butler, Garfinkel, Charles Taylor and Schatzki, and points to a number of common roots in the later work of Wittgenstein and early Heidegger. From this diverse body of thinkers, Reckwitz (2002) and Schatzki (1996; 2001) derive the outlines of a coherent approach to the analysis of practice.

The basic contention is that practices are the fundamental unit of social existence: 'both social order and individuality ... result from practices' (Schatzki 1996). For Reckwitz (2002), theories of practice consequently overcome the limits of classical models of human action and social order grounded in the rational purpose-orientation of *Homo economicus* or in the norm-driven action of *Homo sociologicus*. In common with other cultural theories, theories of practice emphasize tacit and unconscious forms of knowledge and experience through which shared ways of understanding and being in the world are established, through which purposes emerge as desirable, and norms as legitimate. What distinguishes theories of practice from other strands of cultural theorizing is their location of the social. Rather than existing in mental qualities, in discourse or interaction, the social exists in practice. In elaborating on this point, Reckwitz defines a practice as:

> a routinized type of behaviour which consists of several elements, intercon-
> nected to one another: forms of bodily activities, forms of mental activities,
> 'things' and their use, a background knowledge in the form of understanding,
> know-how, states of emotion and motivational knowledge. (Reckwitz 2002:
> 249)

It is all too easy to equate practices with what people do but this is a misleadingly simplistic interpretation. Schatzki's distinction between two different meanings of practice helps in showing how much more is at stake. As he explains, a practice is a coordinated entity: 'a temporally unfolding and spatially dispersed nexus of doings and sayings' (Schatzki 1996: 89). Second, a practice is a performance. By this Schatzki refers to the active process of doing through which a practice-as-entity is sustained, reproduced and potentially changed. A practice-as-entity has a relatively enduring existence across actual and potential performances, yet its existence depends upon recurrent performance by real-life practitioners. Accordingly, practices cannot be reduced to just what people do. Equally there is no such thing as 'just' doing. Instead, doings are performances, shaped by and constitutive of the complex relations – of materials, knowledges, norms, meanings and so on – which comprise the practice-as-entity.

Practice theory therefore decentres the central objects of dominant social theories – minds, texts and conversations – '[s]imultaneously it shifts bodily movements, things, practical knowledge and routine to the centre of its vocabulary' (Reckwitz 2002: 259). As this sentence suggests, practice theories contend with and seek to account for the integration and reproduction of the diverse elements of social existence. This is all well and good, but where do things fit into this scheme? While recent definitions of practice theory make explicit mention of material artefacts, their role is still rather hazy. Warde acknowledges that tools and resources are often necessary. In his words:

> The practice, so to speak, requires that competent practitioners will avail themselves of the requisite services, possess and command the capability to manipulate the appropriate tools, and devote a suitable level of attention to the conduct of the practice. (Warde 2005: 145)

In this account, and in contrast to the theories of consumption we criticized above, objects are not just semiotically communicative: they are also pragmatically useful. Even so, this remains a somewhat limited treatment of things as passive means of accomplishing practices, not as active co-constitutive elements of the practice itself. This restrictive view is shared

by many other versions and articulations of practice theory. Whilst the social is resituated and located in practice, the boundaries of the social remain remarkably conventional. The Latourian contention that artefacts literally construct socialness has yet to be worked through in any detail, but it is nonetheless possible to imagine a more thoroughly materialized theory of practice. In thinking about how this might work out, further questions arise. What part do materials, tools and technologies play in the making, reproduction and transformation of practices? How do constellations of products and practices co-evolve and how do these processes in turn relate to cycles of production, consumption and innovation? An emphasis on practice brings other issues into view, including questions of knowledge and competence. Theories of consumption have tended to emphasize acquisition rather than use and have consequently underestimated the work, the skills and the social relations involved not just in 'shopping', but in the practice-related activities of using, making and doing. Whether one buys the philosophical arguments that surround Latour's work or not, concepts of delegation, the role of non-human actors and the centrality of competence combine with theories of practice to provide a platform from which to extend the study of consumption and of material culture.

In exploring and exploiting this potential, we engage with a range of complex and slippery issues situated at the intersection of different disciplines. Rather than dealing with them in the abstract, we make use of a series of case studies and empirical examples that in combination allow us to address central elements of the agenda sketched above. We have used a mixture of qualitative methods including observations, interviews, and analysis of historical and contemporary documents in studying such varied topics as kitchen renewal, do-it-yourself projects, digital photography, the material culture of plastic and the theories and discourses of product design. The following chapters draw upon new research in each of these areas and to that extent, each can stand alone. However, these different contributions also work together. In combination they take the reader on a winding but nonetheless progressive journey through some of the products, processes and practices that make up the design of everyday life.

THE STRUCTURE OF THE BOOK

We begin this study with an appropriately ordinary question: why do people renew their kitchens as often as they do? Kitchens, which are in many practical respects truly at the centre of everyday life, are the subject of continual transformation and renewal. New appliances arrive, old ones leave and ideas about what kitchens are 'for' are surprisingly fluid. Sociological accounts of the desire for the new focus on symbolic attributes and on the cultural significance of ownership. These concepts inform competing and sometimes compelling accounts of novelty, renewal and acquisition. Yet they miss the pragmatic point that kitchen fittings and household appliances also configure the performances, routines and aspirations of domestic life. Interviews with forty householders about the arrangement, design and use of their kitchens suggest that people modify and replace in an attempt to synchronize or manage gaps between existing possessions and visions of future performance. There is a desire for the new, but it is often as much for a new way of life or new set of practices as it is for a fresh run of kitchen units or a new freezer. These restless itches, which are commonly related to ideals of family life, to notions of competence and to critical moments in the life course, reveal tensions between kitchen design and current and future practice. We argue that this always uneasy balance between *having* and *doing* is a central but often overlooked ingredient in the dynamics of consumption.

Chapter 2's study of kitchen renewal connects theories of consumption with perspectives from science and technology studies by establishing a relation between cupboards, tables and appliances, and the configuration and reproduction of domestic practice. In focusing on processes of acquisition, this chapter represents a first step in opening what is to become a rather more complex analysis of the materiality of practice. Chapter 3, on do-it-yourself home improvement (DIY), takes the story forward with a more detailed discussion of *doing*. Those who have written about home improvement and DIY as a form of consumption tend to focus on the motivation or the end result rather than on the sweat and skill such projects entail. In this chapter we examine the integrative and transformative work involved in changing home interiors. This exercise generates new insights

into the ways in which performances of DIY are structured by iterative and inherently unpredictable interactions with tools, materials and the fabric of the home. These processes result in the successive accomplishment of (or failure to accomplish) the multiple tasks of which DIY projects are formed.

In-depth interviews with a sample of DIY practitioners, together with guided 'tours' of their tool boxes and projects, provide detailed insight into the origins and doing of tasks ranging from moving a radiator through to radically remodelling the home. Informed by this material, we return to the theme of consumer demand, this time underlining the relationality of the 'need' for specific products, and the emergent character of interpretations of utility and value. This discussion serves to highlight the ways in which products are actively assembled and combined with each other as part of the process of consumption. Questions of *competence* prove to be a vital part of this equation and a central theme around which to organize further analysis of the relation between product and practitioner. Technological developments, such as push-fit plumbing or smart paints, reconfigure the distribution of skill in ways that enable certain amateurs to take on tasks otherwise left to professionals, or left undone. Rather than thinking of this as a process of deskilling, we use Latour's concept of hybridity to investigate the complex distribution of competence between persons and things. In developing this perspective, we suggest that planning and accomplishing DIY tasks involves active and transformative interaction between the consumer-practitioner, their toolbox and the fabric of the home. Finally we consider the importance of the *project* and its relevance as a concept with which to frame and analyze the weaving together of component tasks and the competences and materials of which they are composed.

Chapters 2 and 3 get deep into the constitutive role of materials and products in making and shaping different aspects of daily life. Chapter 4 focuses on the more readily identifiable but nonetheless dynamic enterprise of amateur photography. This strategy allows us to map the elements of photographic practice and consider the processes through which it is sustained and transformed. We therefore investigate popular photography as it is reproduced and incrementally redefined by those who do it. Since 2004, digital cameras have outsold analogue models in the UK – a sign

that the photographic industry has undergone rapid restructuring. But what difference has this technological development made to the doing of photography and to the practice as a whole? What do digital cameras mean for traditions like those of taking holiday snaps and pictures of friends and family, and for the habit of organizing and viewing albums? Interviews with practising photographers, ranging from teenagers whose first-ever camera is a mobile phone to retirees recently converted to digital after a lifetime of film, reveal multiple responses, the combined effect of which is important for the trajectory of amateur photography as a whole.

The result is a clearer understanding, first, of the recursive and co-constitutive relations between performances of photography and the practice-as-entity. These are revealed by the complex relation between stability and innovation. Second, by tracking the appropriation of digital cameras we are able to track the role of these devices and their impact on the doing of photography. In addition, we consider the process of recruitment to digital and defection from film. Ultimately, we argue that technologies do not merely configure users; rather, they configure the always emergent practice-as-entity. Similarly, we suggest that technologies are domesticated not only by individual users, but also by photography itself.

In the first four chapters we move between different ways of conceptualizing objects, variously approaching them as technologies (as in science and technology studies); as products and commodities (as in consumption studies); and as artefacts of material culture. In all of this we have yet to take note of the substances of which things are composed. In Chapter 5, we use plastic as a case with which to develop a social scientific analysis of the basic materials of material culture, and through which to engage with further questions about the relation between objects and the stuff of which they are made. Rather than getting into the chemistry of the topic we revisit the cultural history of plastic, analyzing images of the material as embodied and reproduced in individual products. We begin by reviewing utopian visions of plastic's societally transformative potential before analyzing a selection of plastic goods. In discussing the silence of the washing-up bowl, the gaiety of the dustpan and brush, and the unbreakability of melamine 'crockery', consumer magazines of the 1950s (*Good Housekeeping* and *Ideal Home*) provide evidence of how the properties of plastic were initially represented and

reproduced. As we go on to show, subsequent industry sponsored initiatives sought to manipulate the idea of plastic through design. These historical resources allow us to detail the co-determination of plastic's image as a novel or substitute material, and the qualities attributed to specific commodities. By viewing plastic as a synthetic combination of molecules and social-symbolic reference points we argue that studies of material culture could and perhaps should be extended to encompass the social lives not only of objects, but also of material substances.

Our penultimate chapter brings these concepts of product and practice face to face with the 'real world' of industrial design. Designers necessarily have at least tacit theories of how products relate to people. For example, ergonomic research and studies of 'man-machine' systems suppose that objects embody qualities of fit, functionality and aesthetic value, and that these attributes can be enhanced through design. Chapter 6 outlines ideas and concepts around which the design profession has been structured, including views about how people relate to products and about the kinds of values that can be added by design. We do so with reference to histories of the design profession and to cases and examples drawn from interviews with contemporary design practitioners. Having demonstrated what amounts to a dominant discourse of design, we consider the theoretically challenging potential of 'user-centred' approaches, building on these and on the arguments developed in the rest of the book to consider the possibility of what we term 'practice-oriented' product design. The chapter closes with a critical consideration of what this potentially radical move might involve and of what our ideas mean for manufacturers and the designers with whom they work.

The central chapters of the book address different aspects of the relation between objects and the practices and processes of design and consumption. Having underlined the integrative 'work' of consumption and the role of goods in sustaining and transforming different areas of practice (Chapters 2, 3 and 4), Chapters 5 and 6 concentrate on the co-production of ideas and materials, the social organization of product design and associated theories of value. In moving through these chapters we develop a series of interlinked propositions. In Chapter 7 we draw these elements together and elaborate on the significance of our approach for theories of material culture,

consumption, technology and design. We elaborate on the implications of the materialized theory of practice we have developed through each of the preceding chapters. In taking this approach, we share the view that practices, being both emergent and constitutive phenomena, are crucial subjects for social analysis (Giddens 1984). Our further claim is that their reproduction and their transformation involves and depends upon the active integration of materials and of objects, images and meanings, and forms of competence.

Having got this far, the reader might still be wondering why 'design' is one of the five words in the book's title. All of the chapters have at least a tenuous relation to the professional work and intellectual space formally designated as design, and there is one chapter addressing design head on. The activities and ideas of professional designers and design academics have been both a resource and a topic in much of our work. In addition, and as articulated in Chapters 6 and 7, our argument has potentially radical implications for the theory and practice of product design. But this is not a conventional book about design. Nor is it exclusively about design as a professional occupation. Instead, our use of the term reflects its many different meanings: to prepare plans; to fashion skilfully; to intend for a definite purpose; to conceive in the mind, or to formulate a project. In writing about these processes, we recognize the creativity and work of human agents in integrating the complex elements of practice and in weaving practices together in the ordinary but also dynamic accomplishment of everyday life. Rather than following the careers and actions of individual designers, and rather than supposing consumption to be the outcome of intent and planning, we take 'design' to refer to the ways in which practices and their constituent elements are contingently and provisionally knotted together.

CHAPTER 2

Having and Doing: the Case of the 'Restless Kitchen'

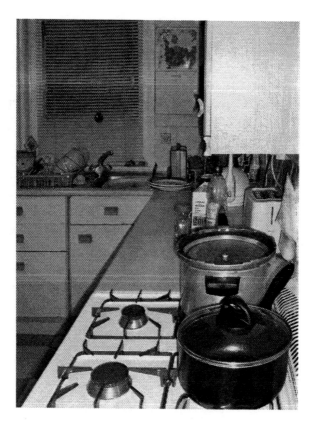

Figure 2 Kitchen

Conran contends that 'the kitchen mirrors more effectively than any other room in the house the great social changes that have taken place in the last hundred years' (1977: 1). Sure enough, the kitchen's role and function within the home, and the activities and technologies it contains, have changed dramatically during this period. New appliances have arrived and old ones become obsolete. While freezers are now common (in the UK, 44 per cent have a freezer and 46 per cent a combined fridge-freezer (Mintel 2001)), larders and pantries have become rare. In 2001, only 22 per cent of UK households had a dishwasher (Mintel 2001), but their popularity is increasing fast. Other developments include the proliferation of kitchen gadgets, tools and small appliances (ONS 2001a; Keynote 2003). Just as important, ideas about what the kitchen is for continue to evolve in ways that have tangible material consequences for renovation and renewal (Freeman 2004). No longer a back region devoted to the preparation of food, kitchens are frequently promoted and represented as places of sociability. Television shows devoted to kitchen makeover both in the UK and North America attest to the popularity of the view that the kitchen should be 'somewhere you want to spend time, where you feel comfortable, where you can simply live your life' (Good Housekeeping 2002: 2). Linking these themes together, this chapter considers the question of why kitchens (or parts of kitchens) are, on average, replaced every seven years or so, and how they have come to be such important sites of consumption.

The notion that people buy consumer goods simply because they need them is more common in everyday life than in contemporary theories of consumption and material culture. When stated baldly, such ideas smack of a primitive kind of functionalism that denies the social construction of desire and bypasses all that has been written about the symbolic complexities of the world of goods (Douglas and Isherwood 1996; McCracken 2005; Schulz 2006). On the other hand, and despite the retrospective rationalization that is almost certainly involved, such explanations allow that things are consumed not for their own sake but for what they make possible. As such they foreground the complex relation between people, things (non-human actors) and activities.

These practical relationships have been overlain and to some extent overlooked by more abstract theories of what Campbell refers to as

consumers' 'continuing desire for the new' (Campbell 1992: 48). Efforts to explain seemingly insatiable patterns of demand make much of the fact that consumer goods function as signifiers of identity (understood as 'performative') and carriers of meaning and cultural capital (Bourdieu 1984; Southerton 2001; Woodward 2003; Woodhouse and Patton 2004). But this is not all they do. There is a physical aspect to material culture and as Latour (1992) and Reckwitz (2002) make clear, things, people and practices interact in ways that are mutually constitutive. These relationships have been analysed by those interested in processes of socio-technical change and innovation and in how material artefacts, rather than being passive objects, actively 'configure their users'. This way of thinking introduces the possibility that consumers' actions and aspirations are somehow structured by the objects with which they share their lives (Illmonen 2004).

In other words, there might be a material or at least a socio-technical dimension to the desire for a 'new kitchen'. Crucially, this might involve the ways in which individual things – specific devices such as kitchen appliances and gadgetry – relate to changing expectations and standards, *and* how the physical architecture or fabric of the kitchen affords or encourages particular ways of doing, and restricts or discourages others. This broader view of the materiality of everyday life raises significant questions about the intersection of design and practice, and especially about what this relation means for future oriented aspirations.

EXPLAINING KITCHEN RENEWAL

In this chapter we review people's descriptions of kitchen renewal, elaborating on the relation between 'having' and 'doing', and on how the material configuration of the home relates to the accomplishment of variously valued forms of social practice. Before turning to these accounts we consider alternative but not mutually exclusive explanations of the rate and extent of kitchen renewal, starting with Campbell's discussion of consumers' desire for the new.

Campbell identifies three interpretations of new: new as freshly created, new as improved or innovative and new as unfamiliar or novel. These

distinctions are important for his more general project of understanding why people 'prefer the new to the familiar and hence desire new products' (1992: 48). The first sense justifies the replacement of items that are deemed worn out. The second is useful in explaining the acquisition of goods that promise additional functionality, though as Campbell points out, innovators often have to persuade consumers that they 'need' things they have not had before. Finally, consumers may simply crave the unfamiliar. All three are potentially useful in understanding kitchen renovation.

A second family of explanations revolves around the observation that homes are key sites of identity and self-expression (Cieraad 1999; Young 2004). If we accept these ideas, replacement and renovation have to do with positioning oneself with respect to changing genres and conventions of symbolic significance. Exemplifying this approach, Clarke argues that 'physically or mentally transforming or transposing their homes, the process in which they are engaged is socially aspirant' (2001: 25). Other commentators argue that design in the form of *style* is important, not in its own right but for how it relates to valued cultural standards and orientations like those of 'respectability' (Madigan and Munro 1996; Southerton 2001). By implication, kitchen tastes and kitchen transformations are caught up in and reproductive of the tides and eddies of social and cultural distinction (Bourdieu 1984; Holt 1997). In so far as the kitchen is a site in which tensions between economic and cultural capital are played out, and in which cultural knowledge and judgements of competent social practice are materialized, so consumers are propelled toward certain forms of acquisition. In a word, the restlessness of society at large is manifested in the micro details of kitchen design and décor.

A third set of arguments focus more specifically on the kitchen as a trace or record of the social, political and economic ordering of domestic life (Conran 1977). Design historians like Johnson and Lloyd (2004), Freeman (2004), Sparke (1995) and Cieraad (2002) follow gendered divisions of labour and leisure, tracking the emergence of the modern housewife through careful readings of furniture, floor plans and appliance design (Parr 1999; Nickles 2002). From this vantage point, patterns of acquisition and transformation reflect and embody changing methods of provisioning and household management. These are in turn understood as expressions of

macro-social developments in gender relations, in patterns of employment and in the economy as a whole (Cowan 1983).

A fourth proposition is that 'practices, rather than individual desires ... create wants' (Warde 2005: 137). This places the burden of explanation on changing practices rather than on individual consumers or on the symbolic qualities of what they buy. By implication, consumers 'need' new kitchens and new types of equipment in order to accomplish new kitchen-based practices. These might be eating and cooking but they might also include socializing, playing with children or formal entertaining.

Together, these four approaches – emphasizing desire, distinction, social ordering and social practice – generate an impressive array of possible reasons why people might invest in a new kitchen and why they might pick certain designs, styles and appliances. Though not mutually exclusive there are significant differences of emphasis and orientation. The first two accord primacy to 'novelty' and 'taste' in ways that are largely unrelated to the specific objects involved. A new oven is as new as a new freezer. In addition, they suppose that the *meaning* of ownership matters more than the hardware itself. By contrast, the third and fourth positions attend to the materiality of consumption and the relationship between individual objects and the particular practices of which they are a part.

Our analysis of what people have done to their kitchens and what they would like to do next suggests that there are fruitful ways of drawing these threads together by focusing on the relations between 'having' and 'doing'. Rather than seeing kitchen renewal as the inevitable outcome of an inexorable rise in consumer materialism, or of a simple identification with discourses of consumer choice and self-identity, we argue that it relates to the imagined or real accomplishment of specific practices that are in turn bound up with prevailing discourses of home and of 'normal' or 'idealized' family life (Hand and Shove 2004). We base this argument on the experiences of forty households, including people living in terraced (row), semi-detached and new town houses (suburban or downtown new builds).[1]

Members of these households were invited to describe the qualities and characteristics of their current and previous kitchens and to explain what changes they had already made or would like to make to the present arrangement. As their comments make clear, there is no single kitchen and no

shared model of domesticity to which all aspire. In addition, interpretations of 'normal' practice were common topics of negotiation and debate within individual households (Kaufmann 1998). We come back to these differences, but begin by noticing that investments in new appliances and in kitchen makeovers were commonly desired, anticipated or justified as a means of bridging between the dissatisfactions of the present and an image of a better, or more appropriate future. Having requisite tools and materials was not in itself sufficient for it was also important to 'live up to' the images and ideals associated with them. In effect it was the *relation* between having and doing that counted.

MODES OF RESTLESSNESS

The following sub-sections illustrate three ideal typical formulations: one in which 'having' is out of synch with 'doing' in that respondents lack the necessary materials; one in which having and doing are in balance; and another in which respondents claim that they have the requisite materials but cannot seem to match these with the 'ways of doing' they wish to establish. These formulations allow us to show how consumption and practice are simultaneously structured or designed by past experience and by an image (or images) of the future.

Missing Materials

In describing the inadequacies of their current kitchens respondents from all three house types identified constraints and limitations that prevented them doing things they deemed important, or from doing them as well as they would have liked. They explained, sometimes stoically, sometimes with a quiet sense of satisfaction, how they 'made do', how they 'got by' and what compromises they had to make.

One of the most frequent complaints was about insufficient space. This constitutes a problem when people are unable to accommodate objects they want and could otherwise have. Most of the terraced houses included in our sample had two small rooms upstairs and two down. In these properties

there was no place for a dining table either in the kitchen or in the living room. In describing her wish for a kitchen table, Jane lists the ways in which it would be useful:

> We quite like the idea of having a bit of a table in there for breakfast and lunch like when there's just a couple of us in. It makes it more of a living room ... you see there's nowhere in there to sit at all at the moment ... if we had a table that would be much easier for doing things like painting ... if we had a little cheap table in there they (the children) could use it for things like that, just a bit of company in the kitchen as well as eating, having breakfast. (Jane)

Whether the lack of a table matters or not is a question of orientation. Much depends upon how people value the idea of eating together or of having company in the kitchen, and upon whether the present state of affairs is 'normal', temporary or has arisen because of a change in circumstances. Our interviewees conceptualized 'lack of space' – and hence missing artefacts and appliances – in one of three ways. For some it was a source of dismay and disappointment.

Divorce, unemployment or loss of a second income prompted respondents like Caroline to downsize and in her case move from a substantial semi-detached house to a much smaller terrace. In the following extract she explains how she has been affected by the consequent loss of space and hence of a dishwasher as well.

> Even a small dishwasher takes up quite a lot of space, there's just not enough space ... [in her previous house, she could] put dirty things into the dishwasher. It's just I liked I just liked that sort of its calmness for me, tidiness equals calmness and you can't do it the same in a small kitchen. (Caroline)

Caroline's kitchen-related problems would be resolved at a stroke if only she had a bigger house. Though sometimes unrealistic, wish lists of material arrangements were typically well articulated. Should the missing ingredients ever materialize, respondents had no doubt about how they would be used.

The depth of discontent often related to perceptions of the current situation as a permanent or temporary state of affairs. The promise of future

improvement made it easier to cope with the limitations of the present. On this basis Sandra spent years putting up with what she viewed as a defective kitchen.

> They've all [kitchen units] got a bit worn so I started from scratch.
> Interviewer: *But that was some years after moving in, how did you manage in the meantime?*
> It was a bit hard but I managed, you just put up, don't you. (Sandra)

While some suffered, others made alternative arrangements to neutralize the effects of missing materials in the kitchen. Heather is, for instance, proud of her ability to maintain standards and achieve desired results with seemingly inadequate resources. In the following extract she reports on recent changes in her home. Instead of upgrading the kitchen, this family has installed a range of appliances in the garage.

> The kitchen per se hasn't been affected. However, because it's so damn small, we essentially utilized part of the garage as part of the kitchen.
> Interviewer: *So what's in the garage then?*
> Some units, fridge, freezer and an oven. (Heather)

Cooking in the garage is awkward but it is a solution that allows Heather to prepare and produce the sorts of meals she wants. This is a rather unusual situation, but respondents from all house types described what is best characterized as a continual negotiation between 'need' and thrift, illustrated here by Lesley's approach to her kitchen worktop:

> The worktop is now very aged and showing its age and could do with changing. I'm not so poor that I can't afford to do that, but if it's not broke why fix it? (Lesley)

In most of the cases considered above, the gap between having and doing constitutes a kind of 'itch' or source of restless unease. For whatever reason, something is not quite right. These personal experiences relate to more general trends in convention and expectation. Caroline is, for example,

missing a dishwasher because she had become used to having one around. That the lack of a kitchen table constitutes a source of dissatisfaction tells us something about changing ideas of what kitchens are for. Although living in the present, Jane and others like her are constrained by kitchen arrangements that embody past understandings of home and family life. Disequilibria of this kind were common, but especially so for respondents struggling to fit a contemporary way of life into the unforgivingly inflexible form of a Victorian terraced house.

Having and Doing in Balance

In this section we consider the responses of people who had, by their own account, all the materials they wanted in relation to the kitchen and who used these in reproducing practices in accordance with their own ideals and aspirations. New arrangements would probably be required at some point in the future but for the time being, the existing material fabric and the ambitions and aspirations it makes possible were pretty well aligned.

The relation between having and doing is not simply determined by affluence, yet those living in larger semi-detached houses were on the whole more likely to describe arrangements that were temporarily in balance. Some kept pace with changing needs and expectations by continually altering the material environment. Robert described just such a process of active adaptation:

> We took the pantry out ... to get more stuff in, cabinets and things like that.
> Interviewer: *Why did you get rid of the hatch?*
> Because we couldn't put any cabinets on that kitchen wall. Before, we didn't have as much stuff. (Robert)

John and Angela also had complete confidence in their ability to realize and materialize new ways of life. In their words, they had 'more money than they knew what to do with' and were therefore able to acquire and replace domestic appliances without hesitation. Now their children have grown up, they plan to move to a slightly smaller house. There is no question that they will be able to do so, and no doubt that they will arrange this new home to

suit their new requirements. By acquiring and disposing of material artefacts as their routines and practices evolve, this couple manages to keep having and doing in balance even when circumstances change.

For others, equilibrium was the outcome of stability rather than constant adaptation. This is how Margaret represented her breakfast kitchen:

> I'd always fancied a big breakfast kitchen. This does not fulfil it to that degree but it is decent and people do congregate there when I'm cooking. The idea of a breakfast kitchen where you might even have a settee as well as a big farmhouse table and chairs in … so very much the social centre as well as the cooking centre. Those two things for me go hand in hand. That is a part of my core family value really. (Margaret)

Sometimes having and doing just happened to match. More often, this was the result of deliberate forward planning. In 1984, Harriet and Geoff set out to design a 'future-proof' kitchen. They took every possible precaution to ensure that this long-term investment would be durable yet flexible enough to meet their needs for years to come:

> It's a German, imported [kitchen] quite expensive, but it still serves its purpose. When we had the kitchen designed we tried to look ahead into the future into what you'd expect to find in a kitchen of that standard and that involves obviously you would have needed a microwave, we have an oven in there and dishwasher… We were quite ahead of the game. (Harriet)

Whether through foresight, a relatively stable lifestyle or an ability to recon-figure in response to changing needs, these people managed to minimize or stave off moments of mismatch between what they aspired to, what they have and what they do. As others acknowledged, all forms of 'balance' are precarious. Joanne, who is planning a family, mentally redesigned her home in anticipation of that event. When she has a baby she will:

> definitely have a table in the kitchen – I wouldn't necessarily have a dining room. I'd probably have this as a playroom, or possibly our lounge is quite big, possibly a lounge diner. (Joanne)

Meanwhile, Jackie wondered about how to fix things so that her family could eat together, not now but in the future:

> We just eat off trays in front of the telly, which is fine and has suited us for the lifestyle we've got but when the children are older I'd like us to all sit down for a family meal of an evening. (Jackie)

For this to happen, Jackie will need a table. But a table alone is not enough. As discussed in the next section, her family must also adjust to a new routine.

Unrealized Practices

The third scenario is one in which people have all the hardware they need but find that having and doing are still out of synch. Such situations are familiar. Sheds, garages and kitchen cupboards are full of objects acquired by people who intended to become campers, cyclists or home bread-makers but who have not got round to putting these ambitions into practice. In discussing this form of consumption, Sullivan and Gershuny (2004) suggest that ownership can be symbolically important even when goods are stored away or rarely used. This may be so for some. However, most of our respondents were quite keenly interested in making things 'work', and in configuring material arrangements so as to foster or 'script' very particular forms of family life. Mick and Barbara reorganized their kitchen fittings and furniture with the explicit aim of changing patterns of social interaction. The result was not entirely what they wanted:

> We've completely revamped it, put a brand new kitchen in, we've extended partly into the garage to make it bigger ... well, there's a TV in there [kitchen]. We haven't got a TV in here, in the sitting room, so we don't ... [we wanted to] have a nice room without a TV. And of course we never use it [the sitting room] because the TV's not here. (Mick)

Rather than spending time in the 'nice' sitting room, everyone now gathers to watch the television in the kitchen. Having designed their home improvements around a different model of social interaction this couple was

disappointed: they had failed to live up to their own ideals. In thinking about what their new kitchen should be like, Tom and Fiona negotiated between contrasting pictures of domestic order. Were they really going to be tucking into bowls of hearty home-made soup, or should they plan for muddy shoes and dripping laundry? Around which imagined scenario should they design their home?

> When we were doing up the drawings we had a lot of discussion over whether to have the utility room separate or knock it in to one enormous big kitchen. I wanted the utility room and my husband wanted the bigger kitchen ... he kind of had these sort of ideas ... home made bread and hearty soups and things, you know things like that, but I said it was better – I'd prefer to have somewhere to leave things to dry, dirty shoes, wet coats, things like that. (Fiona)

In both cases, kitchen design represents a template for action shaped by future-oriented images of family life. Discontent sets in when these images are not realized in practice. Similar disjunctions arise when individuals fail to meet their own standards or those that others (including non-human others) expect of them. For example, a number of respondents talked about the challenge of keeping their possessions 'under control'. As they explained, there is something of a tension between accumulating 'stuff' and keeping it tidy or at least out of sight:

> I've got far too much kitchen equipment I keep throwing it out and throwing it out, I mean if I part with my kitchen bowl I am parting with half my life, but the only thing is now that a lot of them [objects] are getting a bit more difficult to reach. (Joan)
> I've got to be ruthless now and throw the bulk of it away ... I'm going to halve the number of pans that I need, I'm really going to be ruthless ... I don't need three fruit bowls. (Carol)

These extracts point to an aesthetic of order. For Joan and Carol, but not for everyone, a nice kitchen is not cluttered nor does it have 'stuff' stuck all over the doors. As mentioned above, expectations and aspirations vary widely: there is no shared image of family life or of an ideal kitchen, and there are sometimes important conflicts between household members.

Even so, models of rational organization provide a common point of reference and one that is particularly important in structuring ideas about what domestic technologies are for and how they should be used. Domestic appliances are not inherently demanding but they can become so if defined as machines with which to increase efficiency. Six-burner, industrial-scale hobs need not induce guilt but they are likely to do so if associated expectations of sophisticated entertaining fail to materialize. Seemingly generic understandings of what particular appliances are for place the burden of expectation on the individual user. Missing practices are consequently interpreted as failures of individual will or competence. Sarah has not yet managed to shop and cook in ways that her freezer, or rather her mother's view of her freezer, requires. As her experience demonstrates, mismatches of this kind can result in feelings of inadequacy.

> It was ... it was already there, and we hardly ever used it ... this is why I'm trying to now, because my mum says 'you've got this lovely freezer, and you could freeze lots of food and its really going to save you lots of time, and you don't have to go to the shops every day after work and, you can just take something out of the freezer, why don't you make life easier for yourself?' (Sarah)

Again this example underlines the point that restlessness has to do with the relation between having and doing and with the framing of both in terms of more or less precisely specified visions of how things should be.

To summarize, those who have yet to square imagined with actual ways of doing strive to achieve a state of affairs that is for some reason beyond their reach. Somehow the kitchen and the family life it contains have yet to live up to the promises and expectations of the showroom, the traditional farmhouse or whatever the point of reference might be. The result is restless dissatisfaction sometimes accompanied by a sense of failure. Paradoxically, the restlessness of those who lack requisite materials appears more bounded. Often limited by pragmatism and realism, this experience is frequently tempered by a comfortingly positive interpretation of the value of making do.

In reality, these three modes are not exclusive: the same individuals referred to situations in which materials were lacking as well as to those where having

and doing were in balance or in which practices were as yet unrealized. Yet there was some pattern to their experience. Those living in terraced and town houses were more likely to report missing materials than those in semi-detached homes who were, in turn, more likely to describe deficiencies not in having but in doing the things to which they aspired. As might be expected, experiences also related to the life course, younger people being more likely to talk about temporary arrangements and holding patterns than older more 'balanced' members of the sample. In addition, critical moments like those of moving into a new house, having a child, or having children leave home often had a bearing on interpretations of what family life should be like and hence what material resources were ideally required. These observations point to a more general pattern in which established ways of doing are disrupted, whether by life course events or by the development of new ideas and technologies, and in which adjustments, sometimes involving the acquisition of new goods, sometimes not, are made such that order is provisionally restored. In other words, there is a temporal and a dynamic aspect to the relation between having and doing.

THE DYNAMICS OF HAVING AND DOING

In this section we stand back from the immediacy and the complexity of our respondents' lives and identify three generically relevant features of the having-doing dynamic. First, certain kinds of kitchens and kitchen appliances are expected to engender certain social practices. We consequently found people acquiring things in order to *induce* new practices, for instance, designing kitchens in order to foster and in some cases enforce desired habits like those of making more 'home-made' food, being more 'efficient', or spending more time with others. More abstractly, product developments and design innovations have implications for what people expect in the first place and for how they then conceptualize what is ideal, normal and necessary. By way of illustration, everyone we interviewed had a freezer and most (though not all) could no longer imagine how they would now manage without one. This is not to suggest that there is a mono-culture of freezing, for our second generic observation is that identical products can be incorporated into

significantly different repertoires of doing, each associated with significantly different visions of family life (Hand and Shove 2007). Persistent failure to live up to expectations and imagined futures is an important source of restlessness and an indication that technologies, alone or in combination, are incapable of generating new habits and conventions. Equally, it is misleading to view kitchens and their equipment as entirely passive tools with which individuals realize aspects of their identity. Instead, the point is that new demands, injunctions and forms of practice arise as social and technical systems co-evolve (Bijker 1997).

Last but not least, our interviews demonstrate the extent to which present practices are structured by images of the future. In writing about the significance of imaginative pleasures for consumers and advertisers alike, Campbell identifies a cycle of 'day-dreaming, longing, desire for the new, consumption, disillusionment and renewed desire which is entirely inner-directed and does not depend on processes of imitation and emulation' (1992: 61). Although they had ideas about the future, our respondents were not abstractly dreaming about the consumer goods they might one day own. Nor were they content with merely owning things which symbolized an 'imaginary future' (Sullivan and Gershuny 2004: 88). Instead they contemplated quite specific practices, realization of which required the effective combination of having and doing, or the successful 'management' of the having and doing relation. Figure 3 brings these three observations together in a single model.

This is a rather complicated figure and some explanation is in order. The circle marked 'A' represents current practice. It stands for what goes on in each respondent's kitchen today. As indicated, 'A' is where having and doing intersect. The 'past' area to the left of 'A' reminds us that current practice is organized by existing materials (kitchens, washing machines, etc.) and by prior modes of doing, forms of know-how, traditions, skills etc. 'B' represents future practice – this is the conjunction of future materials and future modes of doing. There are three routes by which persons might move from 'A' to 'B':

Route one in which achieving 'B', or realizing the future image of doing demands the acquisition of new materials. This engenders having-oriented restlessness.

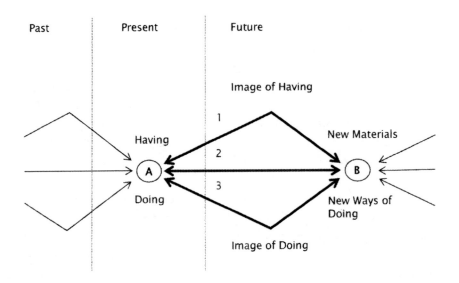

A Present practice
B Future practice
1 New or not yet acquired materials required for imagined ways of doing
2 Having and doing in balance, now and for the immediate future
3 New or not yet realized ways of doing

Figure 3 The dynamics of having and doing

Route two in which 'B' will simply transpire. In this case, 'A' and 'B' are
 pretty much the same.
Route three In which achieving 'B' does not require the acquisition of
 any more materials (appliances, kitchens etc.) but involves
 making different use of what already exists, or doing things
 differently.

Future images of having and of doing bear down on current practice. In
addition, and as indicated by the arrows moving off to the right of 'B',
cycles of restlessness repeat. Like 'A', 'B' is shaped both by the past and by
anticipations and expectations of the future.

In emphasizing the *relation* between having and doing, this figure provides an implicit critique of analyses of consumer culture that focus exclusively on the symbolic surfaces of taste. In the cases considered here, acquisition is not limited to the signification of difference, the performance of self-identity, or the pursuit of novelty for its own sake. Instead, and as the figure suggests, consumption is organized in terms of past, present and future practice. At least in the kitchen, things are acquired, discarded and redesigned with reference to culturally and temporally specific expectations of doing *and* of having – not of having alone.

This model also allows that there are several ways in which having and doing interdepend. Preda argues that objects enable the development of common practices and shared ways of stabilizing and structuring time, and so contribute to specific forms of social order (1999). Although they use different words, the respondents we have quoted make this point time and again. It is not just that consumer goods are implicated in the construction of preferred ways of doing, that freezers demand certain forms of shopping and cooking, or that bread-makers make people make bread. The more diffuse but in a way more pervasive point is that kitchen practices are organized by, through, and around a physical landscape of material possibilities. It is in this sense that we observe an enduring connection between 'doing', and the appropriation of specific artefacts and of kitchen spaces *as a whole*.

In emphasizing the temporal location of present practice we argue that it is structured by future images of having and doing but in ways that are at the same time anchored in the past. The conclusion that future images are materialized in the present has interesting implications for the conceptualization of consumption and demand. Two points are especially relevant. First, this model suggests that the synchronic convergence of materials and practices into contemporary configurations and patterns of everyday life is of immediate relevance for actual (as opposed to imagined) pathways of future development. In addition, it provides a generically relevant method of thinking about how new materials and circumstances engender new expectations and practices, whilst also explaining diversity and variation in the detail of what this means.

So far we have said little about specific sources of restlessness or about why kitchen renovations take the form they do. Many actors have a stake in promoting and standardizing what they hope will become the conventions of the future, and there are powerful commercial interests at play. The idea that kitchen units should match and appliances conform to a single stylistic order was, for instance, critical in making it possible to conceptualize and to buy and sell 'the kitchen' as a singular commodity. General tendencies of this kind, along with others in food provisioning (hence the need for the freezer), and in concepts of family life (hence redefining the kitchen as a living room) reflect and are of consequence for the ideals, practices and designs of everyday life. At the same time, it is necessary to appreciate intersecting constraints like those associated with the existing housing stock and with differences of cultural orientation and social class. As illustrated in Figure 3, variations in normal and ordinary practice, and hence in patterns of consumption, are anchored in the past, present and future. In other words, a household's 'moral economy' (Silverstone and Hirsch 1992) is as important for what its members *do* as it is for the taste-based judgements and lifestyle identifications embodied in what they *own*.

If we are to understand why kitchens are on average renewed every seven years or so, we need to understand the multiple types of restlessness and modes of social and material contentment that lie behind contemporary patterns of consumption. In response, we have argued that space, tools, appliances and other forms of kitchen equipment matter for what people actually do. Their engagement in specific practices is not only a question of identification, and as such neither is their ownership of this or that device, home, kitchen, or any other requisite material. In so far as doing is inseparable from the reproduction of everyday life itself, and to the extent that specific products are necessary for the effective accomplishment of practice, they are indeed 'needed'. This provisional conclusion raises further questions about the reproduction and transformation of practice, aspects of which are taken up in the chapters that follow.

In writing about kitchen renewal we have concentrated more on the motivation for having, and on the past, present and future orientation of acquisition, than on the detailed enactment of doing. Themes of competence, skill and effective accomplishment have been implicit, particularly in

our discussion of attempts to align having and doing, but we have yet to consider how patterns of know-how and expectation form, or how products are at this level implicated in the definition and formation of projects, practices and patterns of consumption. These are the central topics of the next chapter, and of our analysis of home improvement and the dusty realities of literally *doing*-it-yourself.

Consumption and Competence: DIY Projects

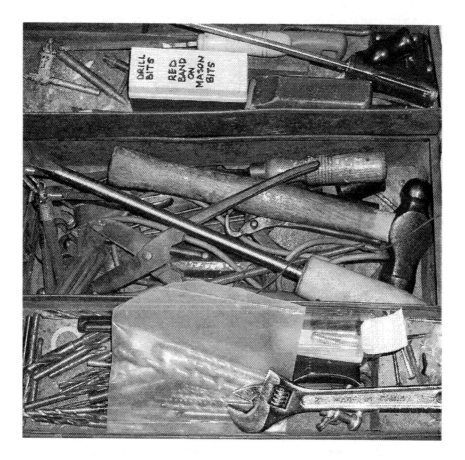

Figure 4 Toolbox

In the previous chapter we considered the practical consequences of the typically unstable relation between 'having' and 'doing' for the restless process of kitchen renewal. Moving between the study of consumption and techno-logy, but remaining firmly within the realm of acquisition (whether real or imagined), we argued that aspirations for the future are materially as well as symbolically configured. In this chapter we examine relations between products and people as revealed and reproduced, not in end results, or in moments of acquisition, but in the practicalities and processes of effecting change. We pay particular attention to the notion that in some – and perhaps in many – fields of consumption, products are actively implicated in the configuration of skill, in framing what people are willing and able to do themselves, in the dynamics of practice, and hence in related forms of consumption and demand. This is an intriguing and unorthodox position for it suggests that the hardware of consumption is of some significance for demand, and that practices – the bedrock of consumption – do not develop independently of the materials on which they depend. We pursue this line of argument with reference to an empirical study of DIY projects and those who do them.

Campbell's (2005) recent discussion of the 'craft consumer' provides a plausible model and a useful point of reference. For Campbell, craft consumption entails the application of 'skill, knowledge, judgement and passion' and results in the production of something 'made and designed by the same person' (Campbell 2005: 23). In these respects, craft consumption is very much like craft production of the type valued by thinkers such as Marx, Veblen and Morris, all of whom viewed it as an authentic expression of humanity in contrast to the alienating production processes of industrialization. The key difference is that Campbell's version of craft consumption is inextricable from mass production. It is so because craft consumers are frequently involved in making connections and producing assemblies and creations that may 'consist of several items that are themselves mass-produced retail commodities' (Campbell 2005: 27). Campbell restricts the definition of craft consumption to instances in which demand is generated by consumers engaged in the skilful process of constructing recognizable assemblages that are more than the sum of their parts, and singles out cooking, creating outfits and entire wardrobes of clothing,

and DIY, as examples. In Campbell's analysis, craft consumption requires a measure of self-confidence, reflexive awareness and cultural capital. He implies that it represents an essentially bourgeois desire for self-expression and an effort to resist the alienating effects of mass consumption.

For the purposes of our argument, the key point in this account is that consumers are viewed as knowledgeable actors whose consumption is in some sense an expression of their capabilities and project-oriented ambitions. In such situations, the relation between product(s) (what is consumed) and practice is likely to be active and generative for the formulation and accomplishment of future projects, and hence for future patterns of consumption. Although Campbell does not say much about the projects in which craft consumers are engaged we suggest that the emergent qualities of experience and practical engagement are crucial. As we argue below, new possibilities of practice – and hence of consumption – arise as individual careers and collective trajectories unfold. In what follows, we elaborate on the dynamic relation between product and practice through a critical investigation of one area of 'craft' consumption.

There are several reasons for choosing to focus on DIY. First, it constitutes a significant but relatively unexplored domain both of consumption and of practice. The market research company, Mintel, defines DIY as 'repairs or additions to the home or garden, including installing a new bathroom or kitchen, central heating, putting up shelves, fixing a fence, building a barbecue etc.' Despite periodic ups and downs, spending on DIY/decorating has been growing at a fairly steady rate of around 7–8 per cent per year since the late 1990s (Mintel 2003; 2005). Around 62 per cent of the UK adult population claim to participate in DIY, including decorating – a separate category defined as 'internal and external painting, staining or wallpapering' (Mintel 2003; 2005). Such activities account for around 13 per cent of the time spent on house-related activities in 2000 (ONS 2001b)[1] and generate a market for related products that is currently worth around £12 billion per year in the UK. Second, DIY is a field in which the relation between tools, materials and competence is plainly significant. As such it allows us to investigate the characteristics and qualities of specific combinations of skill and consumer goods (here including tools and materials) involved in accomplishing projects such as the renovation of a room. Third, the process

is typically transformative, both of those involved and of the physical objects and structures on which they work. One round of DIY has implications for what might be tackled next and for the confidence, or otherwise, with which new projects are approached. As a result, practitioners' 'careers' – both individually and collectively – determine related forms and types of production and consumption.

In-depth interviews with a small sample of committed DIY practitioners provided an opportunity to explore these more abstract issues through detailed discussion of past projects, future ambitions and the history and current contents of the household toolbox. This qualitative data, together with a tour of the respondent's home and of the changes they had made to it has generated relevant insight into the experience of doing DIY. Our fourteen respondents – seven men and seven women – ranged in age from early twenties to mid seventies. Additional interviews were conducted with representatives of organizations involved in designing and manufacturing DIY tools, or in DIY retailing, and with a couple of professional painters and decorators. Further information was acquired through observation at DIY stores and documentary analysis of sales materials, instruction manuals and handbooks.

We draw upon these data in briefly reviewing the development of DIY as a legitimate and increasingly normal practice, and in analysing the terms in which it is defined and justified. Having considered different rationales for doing it yourself, we concentrate on the process and on what the experience and practice of *doing* means for related forms of consumption. Our interviews point to three critical relationships and it is around these that we organize the main body of our discussion. The first has to do with acquiring and owning tools, and with concepts of 'need' and 'utility', interpretations of which proved to be individually and situationally specific. The second concerns the dynamic of competence and the manner in which skills and experience develop through doing, consuming and using. The third relates to an ongoing dialogue between person and property through which actual and potential projects are conceptualized and realized. In conjunction, these three dimensions of DIY inform what we might think of as a practice-based interpretation of demand mediated through iterative cycles of competence and confidence. Such an interpretation suggests that in transforming

distributions of competence, products influence the emergence of projects, practices and patterns of consumption. Before getting into detail we begin by commenting on the history and characteristics of doing it yourself.

INTRODUCING DIY

People have cared for their own homes throughout history and across cultures. Yet the label 'DIY', and the possibility of bounding a field of activity as a referent for that term, is historically and culturally specific. According to Gelber (1997), the phrase Do-It-Yourself, which was used in US advertising as early as 1912, did not become common currency until the 1950s. However, its taken-for-granted application to a distinct set of activities and its contraction to 'DIY' seems particular to the UK in the late twentieth century. Some of this cultural specificity remains today. For example, two of our respondents, both lifelong and second-generation 'DIY-ers', and both from the United States, had never heard of the term before arriving in England.[2] Differences of terminology complicate the task of locating scholarly discussion of the subject, but this is not the only problem. Despite its scale and significance as a social phenomenon, DIY does not figure prominently in social scientific or historical analyses, either of leisure or of consumption.

It is nonetheless possible to identify relevant trends in the making of DIY. Until the development of dedicated DIY stores in the 1970s, people who wanted to decorate, repair or modify their own home had to venture into the specialized world of the traditional builders' merchant (Roush 1999). The very idea of DIY arguably developed alongside, and was undoubtedly promoted by, companies making and selling tools and materials to amateur rather than professional customers. Although power tools were widely used in the building trade long before, they did not find their way into the domestic market on any scale until the mid twentieth century. In recent years the range available to the home DIY-er has expanded dramatically. At the same time, prices – especially of basic items like the 'entry level' power drill – have dropped spectacularly. Although the general trend remains one in which professional models are adapted for less demanding domestic use,

some power tools have been substantially redesigned from the bottom up with the amateur consumer explicitly in mind (see, for example, Black and Decker's multi-functional Quattro, or B&Q's ergonomic and zoomorphic Sandbug). Other innovations, for instance in materials like fibreboard (MDF), in plastic (plumbing) and in fixing technology (especially glues) have transformed the field and extended the range of what the 'ordinary' handyperson is willing and able to tackle.

While methods of retailing and new product ranges have helped define DIY, sources of consumer competence and confidence are also critical. Woodwork, sometimes metalwork and more recently, craft, design and technology have figured on UK school curricula – at least for boys – since the nineteenth century. Schools continue to teach children how to handle materials and tools and have equipped at least some of them with the confidence to tackle DIY projects and use power tools at home. A rather different source for the normalization of DIY has been the rise of home improvement and makeover shows on daytime and prime-time TV. In the view of our industry respondents, these shows fail to transmit meaningful knowledge or impart the skills required to tackle the jobs they represent, but are impressively effective in inspiring many householders and giving them the possibly misplaced confidence to tackle relatively ambitious projects.

These separate influences (manufacturers, retailers, schools and the media) have arguably combined to make DIY something that 'ordinary' households might do. Given that participation is culturally and practically possible, further questions arise: who actually does DIY and why do people spend time and money in this way?

ACCOUNTING FOR DIY

Statistical analyses of large data sets such as the American Housing Survey (Pollakowski 1988; Bogdon 1996; Baker and Kaul 2002) and the Scottish House Condition Survey (Littlewood and Munro 1996) have been used to identify generic correlates of decisions to undertake home improvement and whether or not to employ someone to do it. For example, Pollakowski (1988) finds a strong and clear association between age and the likelihood

of a household undertaking DIY, but a more complex relation with income. According to Bogdon (1996), renovations are most likely to be undertaken by recent movers. Baker and Kaul (2002) notice that changes in household composition affect the probability of home remodelling and Bogdon (1996) finds that household composition matters: multiple adult households are much more likely to do DIY than single-parent families. In addition, people are more likely to employ a contractor when dealing with large-scale, complex or risky jobs and to reserve other 'easier' tasks for themselves.

At the micro level, market analysts conventionally assume that DIY represents a rational response on the part of those who cannot afford to pay for external labour (Williams 2004), or who want to increase property values by means of home improvement. The notion that people seek to maximize actual or anticipated returns on investment is at the heart of neo-classical economics:

> The sphere of consumption itself takes on some of the characteristics of commercial life: working out how to maximise retirement income, treating one's home as a business investment and so on. (Keat and Abercrombie 1991; in Slater 1997)

Industry and retail commentators also share this view, routinely attributing growth in the DIY market – especially since the late 1990s – to a buoyant housing market combined with an increase in home makeover and property development shows on television. A B&Q stock manager puts it this way:

> Well the big thing with the DIY market is that it all came at once, the TV programmes, massive house price movement so people are moving house at the same time, so there was a massive boom.

Decline is routinely explained in exactly the same terms. A drop in B&Q's profits in 2005[3] is for example attributed to a reining in of consumer spending:

> Consumer spending in the year was increasingly impacted by high levels of household debt and rising taxes, as well as higher utility and fuel bills. Concerns about the outlook for the housing market further impacted the

home improvement sector, as seen in the 3.7 per cent decline in the household goods market (ONS) and an estimated decline in the Repair Maintenance and Improvement market of nearly 4 per cent in the year, the weakest market for over 10 years. (Kingfisher 2006)

In so far as they limit and shape household priorities, macro economic circumstances clearly have a bearing upon the DIY market. However, and as is repeatedly highlighted in the literature (Bogdon 1996; Williams 2004; Mintel 2005), ability to pay underdetermines the decision to DIY. Economic arguments often figured in our interviewees' accounts of their own DIY histories and projects, but real-life narratives were rarely that simple. For example, a number of respondents had the means to employ a contractor, but were unwilling or unable to identify and pay someone else to produce the distinctive and innovative solutions to which they aspired and which they knew they could achieve themselves. Karen and John, a young couple renovating a small flat in central London, invoke these sorts of claims in explaining why they do DIY.

When we realized we couldn't afford anything that we really liked. And also, the stuff that you do pay more for its not something that we like anyway. (Karen)

Household economics is a relevant but not sufficient explanation and in this, as in other cases, issues of quality and control were just as relevant. For example, Martin explained that he did DIY because he was convinced that 'no-one can do a better job than me.' More negatively, the effort of finding a tradesperson to do the work and the trauma of having someone else in the house, combined with the risk of getting a botch job or of being ripped off, constituted powerful reasons for doing it yourself.

As these responses indicate, DIY sits awkwardly between conventional sociological categories like those of 'work' and 'leisure', and of consumption and production. According to Mintel's consumer research (2005) over 25 per cent of UK adults enjoy DIY and 8 per cent go so far as to identify it as a hobby. These figures provide only limited insight into what makes DIY rewarding – is it the process itself, the exercise of existing competence, the challenge of learning new skills or the satisfaction of the result? – yet they suggest that there is a significant minority for whom DIY represents

an effective arena for creativity, self-expression and fun. As market research data also confirms, this sometimes involves pursuing ideals, images and aspirations formed and disseminated by the mass media and fuelled by massive retail corporations.

In reflecting on reasons for doing DIY, we have initially touched upon explanations that view the consumer as a rational actor (saving money, increasing property values); as a 'dupe' lured into new ways of spending time and money by TV programmes, magazines and DIY stores (Slater 1997); and as a figure engaged in absorbing forms of self-expression (Woodward 2003). Interestingly and – given the subject – paradoxically, these accounts *all* revolve around the result rather than the process involved. This emphasis is again reflected in social scientific literature which focuses on the effects of DIY in mediating relationships between people, for example, within the family (Nelson 2004); through the maintenance of self-esteem (Woodward 2003); by means of reconstructing space and identity (Miller 1995); or in the consequences of project-definition for modes of provision (Williams 2004) and in-store purchasing (Van Kenhove et al. 1999). It is as if it is only the material effect that is 'consumed' and as if means of arriving at this effect through one's own labour or with professional help is incidental. In other words, such explanations are, for the most part, more useful in understanding why people engage in home improvement than in why they do it themselves. For this we need a more robust analysis of consumption as production and a more thorough understanding of what is literally involved in *doing* DIY.

DOING DIY

What is missing from the accounts considered above, but what a practice orientation undoubtedly requires, is an interpretation that takes due account of the sweat, sawdust, frustrations and satisfactions generated through the active combination of bodies, tools, materials and existing structures, all of which are implicated in repairing, maintaining or improving the home. Although most writers focus on the outcome, some do recognize that the activity is itself significant. For example, Leadbeater and Miller (2004) claim that participation in gardening, sports and home improvement represents

a form of everyday resistance to the alienating effects of contemporary society. More specifically, Miller (1997) writes about the enterprise of making a council house one's own through physical engagement with it:

> The transformation of kitchens was regarded as a positive move that changed the relationship from one of alienation from 'council things' to one of a sense of belonging within a home *created from one's own labour'* (Miller 1997: 17, emphasis added).

Steven Gelber takes a longer-term view of the way in which DIY has been embedded in models of masculine domesticity as these have developed in the US through the early to the mid twentieth century. Gelber (1997) argues that the very ambiguity of do-it-yourself as at once leisure and work, and the centrality of the tools and skills required, have proved important in positioning DIY as a legitimate arena in which men can respond to the expectation that they should play a more active role in the home.

Notwithstanding such isolated acknowledgements of the role of *doing* it yourself, existing discussions attend to the social and cultural qualities of the activity in the most general of terms. They consequently skate over many of the more compelling issues that emerged from our interview data. In particular, they fail to account for the immediate pleasures, challenges, satisfactions and annoyances of tackling projects around the home or for the seemingly autotelic nature of DIY. In talking about their own careers our interviewees explained how one project led to another, how plans were disrupted and diverted in the course of 'doing', and how changes to the fabric of the house reconfigured the range and nature of possible future projects. In the next three sections we draw upon the experiences of the DIY practitioners with whom we spoke in order to describe and analyse relevant features of the process itself.

CONSUMING HARDWARE

To believe that all consumer goods signify social status or that they are always conduits of communication is to reveal that you have not rummaged

through someone's tool store or wandered around the aisles at Homebase, Wickes or B&Q. While the outcome of DIY projects – the new bathroom, the redecorated lounge – may well constitute visible markers of identity, this is not so for the nuts, bolts and spanners involved. As described by our respondents, the majority of DIY-related purchases are pragmatic, driven by the exigencies of projects that are planned or already underway. Put simply, people buy what they 'need' for the job in hand. In thinking about exactly what is consumed, when and why, it is important to notice that individual components are typically useless until brought together in appropriate relation with other artefacts through an active process of assembly. Concepts of utility and necessity are correspondingly specific. To point out that nuts, bolts and spanners *need* each other, or that people buy what they require for the job in hand, is in many ways to state the blindingly obvious. Yet such mundane observations remind us of the need to distinguish between the semiotically significant effects of DIY projects and the pragmatic character of the bulk of DIY-related purchasing.

This distinction is physically reproduced in the design and layout of large DIY stores. For example, some of the new 'warehouse' style outlets contain extensive showrooms featuring 'completed' kitchens and bathrooms. These showpieces undoubtedly figure as sources of inspiration and aspiration yet the reality of the business is that DIY-ers consume not completed kitchens but rather tools, materials and items like screws, rawlplugs, fillers, abrasives, surface preparation products, electric cable, tap washers and drill bits. This is demonstrated by the much greater proportion of space given over to aisles and aisles of stunningly unspectacular products.

On the other hand, and from the consumers' point of view, it is the vision of a completed 'project' that defines and shapes demand and that determines what is on the shopping list. This is something of a problem for the retailers: since the majority of products have so many potential uses it is impractical to group them together in ways that relate to the immediate requirements of individual consumers. The thousands of items on sale are therefore organized according to a recognizable taxonomy which distinguishes between fixings, paints, timber products, hand tools, power tools and so forth. Having set goods out in this way, the challenge is then one of helping consumers first formulate and then accomplish more and less complex projects.

In offering information and advice – through details of store layout, information panels and leaflets and, where present, staff expertise – DIY stores explain what products go together and how component parts should be assembled to achieve the desired result. In the same move, they seek to furnish people with the skills and confidence they need to become practitioners and therefore customers. As DIY retailers are only too well aware, to be necessary and useful, tools and materials have to be situated in proper relation to each other, to the fabric of the home *and* to the competencies and capacities of the DIY-er.

Consumers' toolboxes contain the material traces of such efforts and provide a telling record of the progress of the DIY market, and of product development and retailing. As we were to discover, their contents also reveal much more personal histories of inheritance, exchange, gift-giving and attachment. The extent to which tools were loved and cared for, and the feelings people had for their working with wood, metal or masonry provide an important reminder of the embodied and sensory nature of the enterprise. Experiences of doing and learning were infused with the scent of wood shavings or the smell of plasterboard resulting in strongly evocative, thoroughly materialized memories of projects past. Whether positive or negative, these physical and emotional histories carried through into the projects of the present, and into respondents' orientation to DIY. More pragmatically, but again depending on past experience, some individuals were much better equipped than others. The contrast between more and less extensive collections of tools and spare materials provides further insight into the relational qualities of utility and related trends in specialization and obsolescence.

At one extreme, Anna's toolbox contained only the most generic items: a few screwdrivers, a claw and a lump hammer, pliers and paint brushes. The only power tool in this household was a wallpaper stripper. At the other extreme, Beryl's tools were spread across five different parts of her substantial town house. There were several boxes devoted to hand tools and just about every powered device a DIY-er could want. The tour finally finished in the cellar where, thanks to the luxury of space, Beryl keeps all the tools and accessories she inherited from her father, including some items that she cannot confidently identify, let alone use.

The contrast between these two collections highlights central aspects of usefulness. Hammers and screwdrivers are basic requisites for most elementary forms of home maintenance and there can be few households from which these tools are missing. The all-purpose claw hammer is valuable precisely because of its versatility – it can be used to hit just about anything, and there will always be things which need hitting.[4] Hammers consequently have a role in an extraordinarily wide range of potential projects, as do other relatively 'open' resources such as lengths of timber, filler, nails and screws. Other tools and materials are physically interdependent. For example, nuts go with bolts and screws with screwdrivers: bound by such a close-coupled affiliation that one is of little value without the other. Such technical specialization and interdependence is extremely common, though often existing in less focused form. While they can and often do generate new 'needs', relationships of this kind also result in pockets of obsolescence. One consequence is that sheds, attics and cellars frequently contain tools that have no further function, having been rendered redundant by changes in related technologies upon which they used to depend, by the demise of relevant consumables or the loss of necessary services (e.g. sharpening).

Developments of this kind affect entire classes of previously 'useful' tools, demonstrating relatively large-scale historical trends in the network of relationships through which need and utility are constituted. More immediately, and at the scale of the individual household, the value of different items fluctuates depending upon the projects in hand. By way of illustration, at the time of interview, Karen and John were undertaking extensive renovations with a limited range of carefully chosen equipment. Their flat is very small, they can borrow tools from a network of friends involved with similar projects, and they are reluctant to accumulate bulky possessions because they expect to leave the country at some point in the future. Even so, they bought a Bosch reciprocating saw. This saw was in frequent use, along with a wrecking bar, in the initial destructive phase of work which included removing a partition wall. Now that Karen and John have reached the stage of considered reconstruction the powerful saw is rarely in action and does not make the short list of invaluable tools they would take with them if they were to move. Likewise, a wallpaper stripper,

the tool with which Anna still identifies most, sits idle now that the floral wallpaper has all been peeled away.

As these examples indicate, the 'need' for individual tools, and especially for those whose value is determined by other devices and technologies, reflects generic trends in the technological complex that is small-scale building work *and* the ebb and flow of DIY projects tackled within the household. The toolboxes we investigated underline the extent to which it is the complex of consumer goods – for example, the screws plus the screwdriver or the elbow joint together with the straight connector – that matter more than any one item alone. Many boxes contain things that will never be used, these having been bought as part of a project that has yet to be realized (Sullivan and Gershuny 2004), acquired as gifts, or left over from some previous task and kept, 'just in case' they come in handy. The point here is that with DIY as with other complex forms of assembly and integration, redundancy and utility go hand in hand, both being constituted by the same dynamic processes within the same networks of relationships.

Interpretations of utility are not driven by patterns of technical inter-dependence alone. Most obviously, the same 'necessary' assembly of a drill, appropriate drill bits, fixings and materials, has substantially different potential when in the hands of a novice or of an experienced DIY-er. Likewise, copper plumbing fittings represent just so much metal to those who lack the skills required to fit them together. As the DIY stores recognize, confidence and skill are essential components of 'need', utility, demand and practice. In the next section we consider the development and distribution of *competence*, and the allocation of capacity between the human and non-human actors that are jointly implicated in the doing of DIY.

DISTRIBUTED COMPETENCE

Questions of competence are attracting increasing attention as comment-ators focus on ordinary rather than spectacular consumption, and on forms associated with the effective accomplishment and reproduction of practice (Warde 2005). Many instances of 'craft' consumption suppose and at the same time develop the skills of those involved. As Campbell (2005: 36) observes, practical know-how and related forms of folk knowledge

frequently filter through informal networks of family and friends, and between specialized groups of 'expert' amateurs (de Certeau 1998; Franke and Shah 2003). Self-development is not always a priority but in writing about the contemporary explosion of 'pro-am' pastimes like serious DIY, Leadbeater and Miller (2004) conclude that the satisfaction of acquiring knowledge is one of the central attractions. More pragmatically, knowledge or confidence that one's past experience can be applied and extended is a key consideration for individuals contemplating new and potentially challenging DIY projects.

Conventionally seen as a property of the human subject, the history of DIY suggests that competence is perhaps better understood as something that is in effect distributed between practitioners and the tools and materials they use. In this respect product evolution has important consequences for the ever-changing threshold of doing and not doing it yourself. In the words of a Mintel report: 'product innovation continues apace, bringing new tasks within reach of the amateur DIY enthusiast and making traditional tasks faster' (Mintel 2003). In short, product development has enabled amateurs to take on work which would have been otherwise left undone or contracted out to tradespeople. There are various ways in which this occurs. Power tools evidently make 'lighter' work of physically demanding tasks. Other products modify the relation between process and result. For example, a few decades ago, painting a panel door was a complicated business. For best results paint had to be applied to each section in the right sequence, and time and experience were both required to do so without drags or drips. Today, amateur decorators can choose fast-drying, non-drip, water-based paints that 'know' how to go on to a door: with these technologies in place, even novices can produce an acceptable finish.

If one takes competence to be an essentially human quality, technological developments of this kind represent familiar instances of deskilling. As if to confirm the point, the professional painters and decorators with whom we spoke persisted in using traditional gloss paints in part because the final result, still distinctive from the matt finish of water-based alternatives, provides a tangible demonstration of their skill. Conversely, one might argue that the entire process of painting is not necessarily any less skilled. The point is, rather, that aspects of the competence needed to paint the door have been redistributed between person and technology, the paint

having effectively absorbed capacities previously embodied in the individual wielding the brush.

The implication of this argument is that competence is not only an attribute of the human doing the painting. From this perspective, painting is something achieved only in the *doing*, only as the diverse elements involved in accomplishing the task are brought together, and only as distributed fragments of knowledge – the knowledge embodied in the human, the formal knowledge from the back of the paint tin and the embedded knowledge in the paint, the brushes and their relation to the door – are actively woven together.

The idea that competence is at once embodied in humans *and* in things relates to the concept of human-non-human 'hybrid' (Latour 1993). The combination of a person and a hand-tool constitutes one of the simplest examples of such a hybrid. A human with a rock, a hammer or a power drill

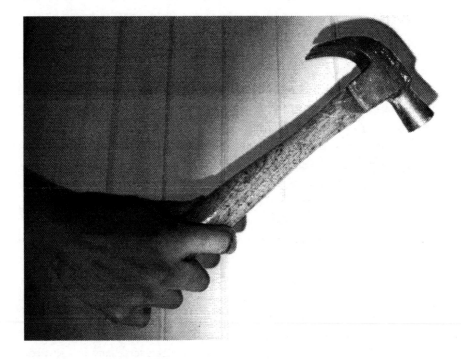

Figure 5 A human hammer hybrid

is an entity with different capabilities and capacities for engaging with world than a one without. It therefore makes sense to see the agent involved in hammering, not as a discrete human subject, but rather as a hybrid of person and tool. Having taken that step, the idea that competence is distributed across human and nonhuman entities is both plausible and potentially useful.

However, the reality of DIY projects confounds any such simple one-person, one-tool interpretation of hybridity. As established in the previous section, tools are useless except when brought into appropriate combination with other tools, with materials and with the structure of the house itself. When we focus on the doing of DIY, the range of this distributed network and the multiple elements of competence at stake are immediately apparent.

The following discussion of Will's attic conversion illustrates the extent to which competence is embedded in and distributed between tools and materials and many other sources including people, DIY manuals and the Internet. Will wanted to turn an attic space into a room for his two young children but was initially thwarted by the layout and by the need to move an existing radiator a metre or so to the left. He had no experience of plumbing and the whole project would have been abandoned had he not learned about Speedfit, a relatively new product range based on plastic push-fit connections. With Speedfit, there is no need to assemble washers, couplings, solder etc. and no need for the specialist knowledge required to fit these elements together with any confidence of success. This is important. In a project of this kind, failure will result in a leak – only detectable when the central heating system is refilled and only curable once the system has been drained down again. Technologies such as Speedfit bring jobs like moving a radiator within the reach of those who lack traditional skills. In Will's case, this was a necessary but not sufficient condition for taking the project on.

Before going ahead Will sought advice from others more experienced than himself and enlisted the help of a neighbour who had previously witnessed a plumber using Speedfit. With the assistance of this neighbour, the form and function of the plumbing fittings and the drawings that came with them, Will successfully shifted the radiator, a task he identified as the most challenging he had ever tackled.

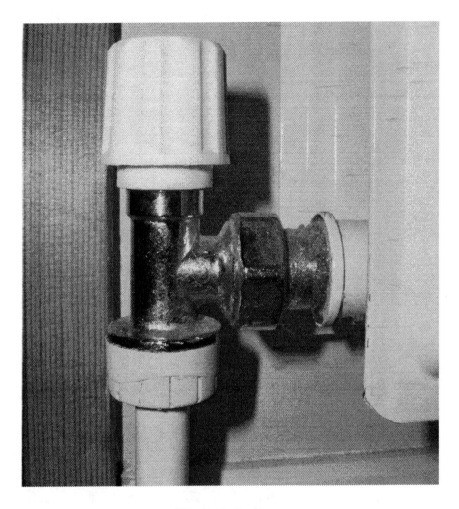

Figure 6 Radiator

In this example, competence appears to be scattered between various humans and assorted material artifacts, including products and instructions about how to use them. Just as important, and as is also evident in Dant's (2005) discussion of car repair and maintenance, these elements, and with them the competence necessary for achieving the job, only come together in the immediate process of accomplishing projects in real time. In trying to

make sense of what goes on in garages, Dant differentiates between embodied knowledge (i.e. embodied in the human subject) and embedded knowledge (i.e. embedded in the objects and materials with and on which the human subject acts) and the role of 'immutable mobiles' (after Latour (1987), here representing intermediaries such as instruction sheets, manuals, etc). In taking a similar approach, we also conclude that the considerable levels of competence necessary to accomplish DIY tasks are distributed between diverse human and nonhuman entities.

This analysis provides new insights into the dynamics of craft consumption. Specifically it situates technological developments – such as intelligent paints or Speedfit plumbing – not as instruments of deskilling and dumbing down but as agents that rearrange the distribution of competence within the entire network of entities that have to be brought together to complete the job in hand. Analysis of the dynamics of what people do and do not do for themselves has to focus on the co-evolution of these hybrid entities rather than on the human or non-human elements alone.

Hybridized and distributed knowledge systems are inherently unstable. They are so not only because of the kind of rearranging described above but also because DIY practitioners (along with flat-pack constructors, mechanics, gardeners and others) learn from experience. Some experiences are bad and some are so bad that aspiring practitioners are put off for ever. However, others serve to increase competence and confidence, and thereby extend the range of possible future projects. In talking about his own DIY career, Ted distinguished between moments of relatively formal knowledge acquisition – these included lessons at school, being deliberately taught by his dad, carefully reading DIY manuals and searching the Internet for advice – and situations in which he drew upon previous experience in figuring out how to approach new tasks and solve unexpected problems as they arose along the way. Ted claimed that his confidence grew through physical engagement with tools and materials, and through the practical accomplishment of specific projects. In reflecting on this process he commented, almost in passing, that individual products sometimes led the way. Elaborating on this point, he discussed his desire for an angle grinder and his belief that with such a device in hand, new grinding projects would inevitably emerge. In this example, Ted points to a further dynamic

in which redistributions of competence have cumulative, co-evolutionary consequences for tackling specific tasks and for the formulation of entire projects.

The range of tools, consumables and materials involved in the vast array of projects that constitute DIY is truly enormous and changing patterns of distributed competence are correspondingly complex. As hinted at above, but not yet discussed in any detail, the relation between specific skills, tools and products is vital for the formulation and realization of complete projects. The notion of 'the project' is central to the forms of consumption and practice with which we are concerned, and it is to this concept that we now turn.

EMERGING PROJECTS

In describing his attic renovation, Will referred to moving the radiator as 'a project', even though this task was but one step in the larger scheme of creating a space in which his children could play. Although fluid and flexible the concept of the 'project' was uniformly important as a way of structuring the otherwise boundless flow of daily life (Zerubavel 1985). Time was set aside for projects, tools and materials were acquired or assembled with the project in mind, and projects were the basic building blocks of individual DIY careers. Used in these ways, the project stands somewhat outside both the streams of practice and the momentary conjunctions of tools and skills that characterize the doing of DIY.

While individuals might well figure as the 'carriers' of practices (Reckwitz 2002: 259), projects have a rather different status. For one thing, they are more obviously 'made' by human actors who weave multiple practices together in the course of defining and realizing the landmarks around which DIY careers are built. Even if they take years to achieve, projects constitute 'orchestrating' forces, condensing diverse resources and energies around specific goals. Tools and materials can and often do 'configure' their users and variously generate or demand specific forms of competence, but their role in framing projects is typically less direct. As Ted's experience indicates, those who own an angle grinder – or who are confident in using one – are perhaps

more likely to formulate projects in which a bit of grinding is involved. Similarly, those who have spare materials to hand often think about how they might be used. In other words, tools, materials and associated forms of competence frame the range of what people take to be possible. But they rarely drive the entire process of 'project' definition.

It is therefore tempting to think of project definition (and of all the consumption that entails) as the outcome of deliberate human planning and of individual decision-making. However, our respondents' accounts suggest that these are not the only dynamics at play and that other terms and concepts are required in understanding how complexes of practice and consumption come together.

Some interviewees retrospectively represented the work they had done as the gradual realization of a 'grand design', driven by a clear vision of how things should be. In this context it is important to notice the relation between concepts of style and project formation. Ideas about interior décor and style constitute 'softly' demanding injunctions, obliging followers to achieve specific standards of coordination and order, and defining the terms and margins of what are sometimes extensive projects. Though some worked to a pattern of this kind, the more common scenario was one in which projects unfolded in the course of an ongoing 'conversation' between a changing household – its composition, routines, accumulation of possessions, etc. – and the physical fabric of the home. Most of the DIY-ers with whom we spoke described an initial flurry of activity on first moving into their current property, and for those who move frequently, this is the only kind of DIY they do. However, people who remained at one address for longer routinely attributed subsequent DIY 'projects' to life events like the arrival of a new baby, the departure of grown children, retirement or changed financial circumstances. These were driven not by a grand plan, by fashion or by the desire to materialize a modified self image (Clarke 2001) but by the ordinary exigencies of everyday life.

Whatever the reason for embarking upon them, there are other more immediate senses in which DIY projects emerge. There can be few DIY-ers who have completed a major project in exactly the way they anticipated, having gone through only the processes envisaged and used only the tools and materials they thought they would need. For any one DIY-er, some

jobs will go exactly according to plan but as a field of activity, DIY is almost inherently exploratory. It is so because of the sheer complexity of coordinating tools, materials, fixings and human expertise, because of the unpredictability of working in relation to an often intractable or surprising structure (i.e. the existing house), and because of the need to adapt and cope with the contingencies that inevitably arise.

Experience removes some of this uncertainty but for most of our respondents, understanding exactly what a project involved and hence what tools and materials would (ideally) be required developed through an iterative process of doing, reflecting and adapting. For example, the initial planning of Will's attic room was determined through discussion with his partner and the children, by the extent of what Will felt he could confidently do himself and by the material reality of an exposed roof timber running the entire length of the room and at a such a height that the children were sure to bang their heads. The final arrangement – in which a small section of the exposed timber formed the entrance to a cozy den and in which the remainder became part of a fixed playhouse – reflected some of this deliberation. However, the precise shape of the playhouse (Figure 7), the size and location of its window and the closing mechanism of the door were determined along the way as Will stretched his carpentry skills to the limit in assembling new and existing materials – wood, nails and screws – with the tools he had to hand.

In this case, nothing went significantly awry and there were no nasty surprises. However, new projects often emerge from the very process of DIY. Stripping the wallpaper can, for instance, reveal patches of crumbling plaster that have to be addressed before the initial project of redecoration can be resumed. Less traumatically, the effective completion of one project can prompt DIY-ers to formulate another. Having removed the floral wallpaper and painted the downstairs walls a nice clean white, Anna felt compelled to replace the patterned carpet left by the previous owners. Although acceptable alongside the 'offensive' wallpaper, the carpet in turn became 'offensive' once the walls had been dealt with (this is a good example of what McCracken (1988) refers to as the 'Diderot' effect).

In both situations, one thing leads to another with what are often unpredictable consequences. In some cases, stocks of tools and skills build up as

Figure 7 Playhouse

DIY-ers resolve unforeseen difficulties; in others, they lead to disillusionment, failure and defeat. Whatever the outcome, the point is that narratives of DIY and associated careers of consumption are typically carried along by a tide of projects, problems, challenges, outcomes, frustrations and future ambitions.

As we have already discussed, the relation between tools, materials and embodied competence is important for the process of DIY. It now seems that project formation also has a material dimension. In some cases projects

are defined with the aim of closing the gap between what the home affords in terms of space, shelving, or style and the changing demands made of it, and another in which projects – in process or once completed – generate new material conditions and new possibilities or requirements for future DIY.

To summarize, project formulation often contains an element of economic rationality, for example, in the idea of adding value and/or in the logic of doing it yourself; there is some evidence of market manipulation, especially in matters of style and aesthetics, and questions of self-identity are undoubtedly important for those for whom DIY is part of making the house a home. However, our respondents also describe other much more emergent, much more contingent aspects of project formation, many of which have to do with pragmatic processes of engaging with their immediate physical environment and the materials of which it is made.

PRODUCT, PROJECT AND PRACTICE

We began this chapter with the idea of building on Campbell's (2005) discussion of the active and creative role of 'craft consumers', and of linking this with the practice-oriented model of consumption proposed by Warde (2005). We also began with the conviction that there is more to be said about the relation between what people consume (i.e. the hardware of consumption) and what they actually do. Our study of home DIY projects and those who do them has indeed generated new insight into the material bases and dynamics of consumption. In this final section, we elaborate on the theoretical implications of these observations and comment on their relevance for other areas of consumption and practice. In drawing the threads of our analysis together we highlight two related ideas. The first is that in structuring distributions of competence, objects indirectly structure possibilities of practice and consumption. Second, and as a move forward from the previous chapter on acquisition, that the *doing* of DIY is itself of consequence for individual careers, emergent projects and future patterns of demand – including demand for objects that indirectly define the possibilities of future practice.

In laying the ground for this discussion we commented on the concepts of utility and need around which so many accounts of DIY-related consumption depend. Some hardware purchases are surely aspirational and many tools are bought but used barely at all. It is nonetheless certain that you need blocks and mortar if you are to build a wall, just as you need onions if you are to make onion soup. In both cases these are quite literally the ingredients required for the project in hand. This kind of pressing need is not confined to cases of craft consumption alone. If we agree that practices consist of 'embodied, *materially mediated arrays*, shared meanings' (Schatzki 2001: 3), it makes sense to reinstate the somewhat unfashionable idea that people buy things because they 'need' them in order to accomplish valued but ordinary social practices. This is not to deny the importance and relevance of sociological and anthropological efforts to demonstrate the interpretive flexibility of objects or the essentially social construction of meaning and demand (Appadurai 1986b). Nor is it to suggest that needs are simply natural, inherent or physically determined. Instead, the more prosaic point, also made by Reckwitz (2002), is that objects – freezers, breeze blocks, onions – are materially implicated in the construction and reproduction of what people do.

Exactly what 'materially implicated' actually means has been the subject of some debate, particularly within science and technology studies. Not all of the resulting literature is of relevance for the conceptualization of consumption and practice but as we have demonstrated, there are potentially fruitful opportunities for cross-fertilization. We have elaborated on three.

First, in underlining the relational quality of utility we made the point that many consumer goods are only of value when brought together in conjunction with each other. In the case of DIY, we observed numerous instances of specialization and technical interdependency. In reality, these are not unique to DIY or even to cases of craft consumption. It is not only nuts and bolts that have to go together: similar relationships, and similar forms of 'necessity' also arise with respect to coffee makers and their filters, Hoovers and their belts, printers and their cartridges and all manner of everyday consumables. In addition, we noticed that many products are only of value when combined with necessary forms of skill and expertise – for those who do not know how to connect them, plumbing fittings are only

bits of metal. Again this is an observation that applies to more than DIY and again it is one that is accepted in technology studies. As Suchman et al. put it: 'individual technologies add value only to the extent that they are assembled together into effective configurations' (Suchman et al. 1999). Partly because they have focused more on moments of acquisition than on processes of use, theories of consumption have yet to pay sufficient attention to relations *between* consumer goods or *between* objects and associated forms of expertise.

Second, in concentrating on this latter feature, and in doing so with respect to DIY, we have explored the possibility that consumer goods – the conceptually invisible stuff of consumption – sometimes have an active part to play in the dynamics of doing, desire and demand. Despite coming from different intellectual traditions the notion that objects can create 'user experiences' (Kuniavsky 2003), configure specific actions (Woolgar 1991) and engender or sustain programmes of social and institutional order (Latour 1992) has potentially important implications for theories of consumption and change. In the examples we have considered, products like non-drip paint, power tools, Speedfit plumbing and MDF have tangible consequences for the distribution of competence. As such these items are potentially important in setting and moving the boundary between what amateurs are and are not willing to do for themselves, and in permitting and sustaining innovations in practice. There is more that might be said but for now, and to summarize this part of our discussion, the proposition that materials and practices co-evolve is critical for understanding the dynamics, certainly of craft consumption and perhaps of other forms as well.

Third, we have made much of the transformative character of DIY. As we have seen, each project and each task of which each project is made is of consequence for the development of competence, skill or disillusionment, and so for the formulation, or otherwise, of future projects. Although often missed in discussions of consumer culture, this temporal aspect is vital in understanding the careers of individual craft consumers and the trajectories of the multiple practices they collectively reproduce and transform. In describing their own histories and experiences, the DIY-ers with whom we spoke routinely referred to the projects with which they had been involved. For them, the project – however loosely defined – was the critical conceptual

unit around which doing and consuming were organized. In discussing processes of project formulation we noticed that many emerged through and in the course of practical engagement between people and the materials and properties with and on which they worked.

We chose to study DIY because it appeared to have certain distinctive and distinctively interesting features: straddling the categories of work and leisure, and of production and consumption; being directly about the engagement of people and materials; and being a field in which competence is evidently important. Sure enough, we have seen how competencies are distributed between human and non-human actors, and how tools and materials are implicated in making and shaping the projects and ambitions of those who use them. Analysis of this arguably special case has allowed us to identify a provisional chain of relationships through which consumer goods are linked to competence, competence to practice and practice to the consumption of consumer goods. Some words of caution are immediately in order. One link does not necessarily follow from another, the ending is not always the same and in any case this is only part of the story. It is, however, a story in which the materials of consumption have an active and constitutive role. Having established that materials are integral to doing, further questions arise about how these elements are integrated in practice and about how they co-evolve. In the next chapter we examine the recent history and contemporary reproduction of amateur photography, using this as a means of investigating these more dynamic processes.

CHAPTER 4

Reproducing Digital Photography

Figure 8 Digital cameras

It would be possible to write about home improvement projects and photography in very similar terms: professional and amateur forms coexist; both involve the integration of a complex of different elements; both require a measure of commitment and competence; and both are orchestrated by concepts of project, loosely defined. Rather than rehearsing these themes again, we use the recent arrival of digital photography as a means of investigating the dynamic relation between new products and variously established habits like those of taking, managing and viewing photographs.

As Latour (1999; 2000) correctly observes the social sciences continue to understate the part material artefacts play in social life. On the other hand, popular discourse routinely overstates their impact. For example, discussions of digital image making frequently imply that it has effectively obliterated photographic ways of seeing and doing to the extent that the digital version barely counts as photography at all (Mitchell 1992). In describing how the technology of photography — the essential 'stuff' of the practice — takes root in individuals' lives and in society, we hope to show how human agents are captured by the practices they 'carry'. Although dealing with digital photography, rather than drug taking (Becker 1963), we too examine the details of being and becoming a practitioner and the dynamic 'careers' of those involved. Moments of capture and enlisting are critical (if there are no new recruits, practices fade away) but if practice is nothing but the routinized reproduction of pre-existing social and technical arrangements how do new forms arise and, just as important, how do some endure and others disappear? In this chapter we are interested in how emergent experiences of taking and sharing digital images accumulate and combine in ways that redefine the character of amateur photography. In addressing these questions we hope to show how technologies configure and are domesticated not only by individual users, but more broadly, by and in relation to the *practices* of which they are a part.

Although we take the practice as the central unit of analysis and enquiry, we base our discussion upon a study of individual photographers all of whom have relatively recently acquired a digital camera. This chapter is consequently informed by nine one-to-one interviews with a selection of amateur photographers; repeated visits and group discussions with members of a local camera club (LCC); a focus group with four 17 year olds; and a

workshop exercise with eighteen 14 to 16 year olds. The resulting material does not allow us to comment with authority on the fate and future of digital photography, but it provides useful insight into the changes and adjustments involved. Our respondents talked about the disruptive, destructive and transformative consequences of 'going' digital. At the same time, their accounts demonstrate how much has stayed the same. Although the range of potentially photogenic situations continues to expand, new methods of image capture and management are used to reproduce remarkably consistent conventions of visual representation. This prompts us to consider the rather complicated ways in which the constitutive elements of practice are embedded, disembedded and integrated as amateur photographers negotiate routes through an always changing landscape of materials, conventions and forms of competence.

Before investigating the digital habits of individuals with very different prior experience, we comment on the characteristics of photography as a practice and its emergence as a popular amateur pursuit. These opening sections set the scene for a more detailed analysis of what is involved in 'going' digital and in then 'doing' digital photography.

INTRODUCING PHOTOGRAPHIC PRACTICE

To speak of photography as a *practice* is to refer to it as a relatively enduring, relatively recognizable entity. It is to assume that photography exists in an abstracted yet identifiable form, defined by, but floating somehow free of the millions of moments and situations in which it is literally enacted. Accordingly, photography can be spoken of as a social phenomenon – the idea of taking photographs makes sense in everyday conversation and in academic discourse. More than that, it exists as something that people can join in, resist or withdraw from. As such, photography is constituted by a recognizable configuration of norms, conventions, ways of doing, know-how and requisite arrays of material things (Schatzki 2001: 3). These defining elements are reproduced and sometimes transformed in the active process or performance of taking, modifying, storing, viewing or sharing

images. While photography exists as an entity transcending moments of performance, it does so only so long as it is performed.

These theoretical statements point to three critical features of photography and of other practices too. First, practitioners have to be captured, enlisted and engaged. To borrow Reckwitz's example, football would not exist if people did not play it (Reckwitz 2002). Second, practices like photography are defined, constituted, reproduced and reconfigured through participation. To continue with the example of football, if people played differently, or if they invented different rules, the game would change. Each performance of photography therefore constitutes a potentially unique conjunction of elements. Third, the elements (of material, of image and meaning, and of competence) that are integrated in practice may themselves evolve, whether as a result of technical innovation or shifts in norms, expectation or know-how. Photography is consequently subject to incremental transformation over successive more or less consistent or faithful moments of enactment.

The history of amateur photography can therefore be told as a story propelled and punctuated by an always changing relation between the defining ingredients of camera and equipment; of what it means to be a photographer, and of what this involves and requires. We comment briefly on three such configurations loosely relating to periods of 'early photography'; 'popular photography' and 'digital photography' in order to track these intersecting trajectories.

The use of a camera to fix an image was established in the 1830s (notably with the introduction of the Daguerreotype in 1837). Despite continual innovation, the cost of equipment and the dedication required to capture and process even simple images was such that photography remained a pursuit of social elites and serious enthusiasts for the next five decades. For much of this period, the weight and bulk of the camera and the long exposure times required restricted the range of photographic subjects. Like nineteenth-century painting, a genre from which photography inherited much by way of aesthetic convention, the core repertoire of early photography was defined by conveniently inert landscapes, buildings and carefully posed and well-disciplined humans.

In 1883, George Eastman began to produce rolls of film rather than single specially prepared photographic plates. This simplified the process

of taking pictures and made it possible to advance frames automatically. Cameras became smaller and cheaper, images could be captured more quickly and in 1901 the first truly mass- market camera, the Kodak Brownie, went on sale for one dollar apiece. Kodak's slogan 'you press the button, we do the rest', represented the deskilling or more accurately the redistribution of photographic competence. The institutional separation of processing meant that the amateur photographer no longer needed to know how to mount a photographic plate and no longer needed to have the facilities, competence and time required to produce a print.

By the start of the twentieth century, cameras were increasingly widely available and increasingly easy to use.[1] As popular photography took hold, and as cameras and films became more versatile, so the range of photogenic situations and subjects expanded. By the 1960s cameras appeared so ubiquitous and photography so accessible that it seemed to have no social bounds of its own. Cameras were technically capable of taking pictures of just about anything at all, and when they were present in most households, what was there to constrain or limit their use? As Bourdieu put it 'everything would lead one to expect that this activity, which has no traditions and makes no demands, would be delivered over to the anarchy of individual improvisation.' Yet, as he goes on to observe, 'it appears that there is nothing more regulated and conventional than photographic practice and amateur photographs' (Bourdieu 1990: 5). While 'art' remained an important point of reference, and a topic of continuing debate (can photography be an 'art' or is it merely a craft?), other genres like those of documentary recording and the family snapshot entered the frame.

Although much has been written about the role of visual images (Sontag 1979), particularly since the 1970s, those few who have studied amateur photography in any detail tend to concentrate on themes of memory and on the significance of albums and photos for individual identity, belonging and family cohesion (Csikszentmihalyi and Rochberg-Halton 1981; Hirsch 1981; King 1986; Chalfen 1987; Spence and Holland 1991; Harrison 2004). This research underlines the point that despite the infinite variety of possible photographic subjects, family albums depict memorable events, holidays and moments of happiness; representations of sadness, routine activities or ordinary and familiar locations are rare. It also indicates

that women tend to be responsible for making and keeping the family album, that first-born children are more photographed than their siblings, that pictures are often very highly prized possessions, and so forth. In highlighting the parallel emergence of social expectations and norms, this literature complements technical accounts of photographic innovation and suggests that film photography is constituted by the camera and by the sets of meanings that define the contexts of its use.

This is not to imply that there is only one accepted form. There are multiple, coexisting, variously structured conventions defining the situations and subjects of amateur photography, the aesthetics of the photographic image and the uses to which pictures could and should be put. For example, some people take and value taking snaps of social situations. Providing key figures are recognizable, technical quality is of little or no significance: the feet may be cut off and the background blurred but the image still represents that glorious day at the seaside (King 1986). Others refuse to engage in 'typical' family photography, instead dedicating themselves and their photographic equipment to the pursuit of artistic effect.

For Bourdieu, these different ways of doing or refusing photography are constituted by (and at the same time serve to reinforce) relations between social classes. Hence, the peasant rejects urban life with the rejection of photography, while the petite bourgeoisie seek to distinguish themselves from the working class and associate with high culture by using photography to perpetuate and demonstrate 'cultural practices which are held to be superior' (Bourdieu 1990: 9).

There are three points to take from this: first, the manner in which people *do* photography reproduces more than photography itself. In Bourdieu's analysis, such doings are also reproductive of social difference and structure. Second, the range of recognized photographic 'styles' is such that identical cameras have different significance in practice depending upon the social and cultural orientation of those who hold them. Third, the diversity of amateur genres is reproduced and sustained in and through the multiplicity of doings, values and orientations that define the field as a whole. In their different ways, practitioners keep their respective 'genres' alive and as we go on to show, many do so despite an influx of new and challenging technological possibilities.

The purpose of these few paragraphs is not to provide a comprehensive history of amateur photography, but simply to indicate that with each move, provisionally established photographic practices have been unsettled and reconfigured. The arrival of digital technology represents another turn in this unfolding narrative.

Until the early 1970s, photographic images were fixed by means of light-sensitive chemical reactions on the surface of a film or a plate. In 1969, Bell Laboratories developed a charge-coupled device (CCD) that converts light into digital data. The CCD is the key technology on which digital cameras depend and around which many forms of digital imaging now revolve. Prototype digital cameras found their first specialist market in photojournalism, a field in which the value of receiving images instantly from around the world outweighed the limitations of poor resolution and the enormous cost of the camera itself. Digital cameras were available on the consumer market in the early 1990s. Early models offered very low resolution for a very high price, but in just a few years digital had developed to the point at which it could compete with film photography across most applications. Increasing volumes enabled economies of scale and the quickening pace of innovation had a huge impact on the industry, not only in camera manufacture but also in film and processing. In the UK, digital cameras outsold those using film in 2004 and are now cheaply available and routinely embedded in previously unrelated devices like mobile phones. Represented like this, the history of digital imaging is a simple tale of technological and commercial success, and of rapid diffusion across a broad constituency of users. Accounts of this kind imply that digital cameras fulfilled existing consumer needs. But there is another parallel story to be told of how digital photography captured practitioners on such a scale and at such a rate, and how it managed to unsettle the routines of a substantial population of amateur photographers. What new conjunctions of material, image and competence does this represent and how might we account for digital photography as an innovation in practice?

Given the wealth of sociological literature on 'information' and on 'network' societies (Castells 1996; Lash 2002; Webster 2004), one might expect the arrival of digital cameras and the relation between these and other technologies like the mobile phone and the World Wide Web to

have attracted instant interest. Sure enough, there are discussions of digital imaging, for example in health care, or as an instrument of surveillance. For the most part, these debates circle around problems of authenticity (trust and truth), privacy, the technical and symbolic nature of image making (Lister 2001), or more abstract issues of identity and post-modernity (Slater 1995; Kember 1998; Lury 1998). Questions about new forms of 'control' over the production and consumption of pictures (Lunenfeld 2000), or about relationships between images as material objects and the symbolic practices they mediate (Edwards and Hart 2004) are also routinely addressed without reference to the ways in which digital cameras are actually being used. As a result there is little existing analysis of the impact of digital technologies on the materials, routines, forms of competence and conventions that hold multiple strands of amateur photography in place.

In the next three sections of this chapter we explore this issue with reference to our respondents' accounts of going digital and of doing digital photography, and by reflecting on the dual processes of recruitment (to digital photography) and reproduction and transformation (of photography as a practice).

GOING DIGITAL

Whatever the motivation, 'going digital' is a moment of defining significance for the details of one's photographic career. This is not to say that photographic performances are necessarily substantially different, either for the individuals involved or for outside observers. But because digital cameras demand new ways of operating, the process of changing or even of holding performances stable requires an active renegotiation of previous arrangements, skills and routines. The nature and extent of this reconfiguration varies widely and in ways that reflect and relate to the settings and environments in which more and less demanding complexes of technology are acquired.

For some respondents, the transition from analogue to digital was of barely any consequence for existing photographic practice. John is in his fifties and has had his Kodak Easyshare C300 for about four months, having

bought it on credit from a catalogue. He aspires to owning a camera with optical zoom, more manual settings, and a higher resolution than his current 3.2Mp but for the moment this basic model fulfils his basic needs. John has difficulty accessing shots on the camera and does not know how to delete them. He has one memory card and when it is full or nearly full he takes it to Boots, using the self-service machine to print out all the photos and clear the card while it is in the machine. The range of technology involved is limited to the camera, the memory card as intermediary (and as a substitute for film), the Boots self-service machine (itself a substitute for the more complex film-developing machine that used to exist in the same store) and the prints that it delivers. John's technological system is effectively isomorphic with that in which his film camera was embedded. This relative stability is indicative of the stability of his photographic performances and their capacity to endure despite going digital.

This configuration lies somewhere along a spectrum of possibilities defined, at one end, by the 'autonomous' camera and at the other by an entangled network of interconnected technologies. Many cameras allow users to edit pictures directly. With this facility, a screen and a large amount of memory, the camera becomes a one-stop device for capturing, manipulating and viewing digital images. At the other extreme, one of the distinctive characteristics of the digital era is the potential to link many technological elements together. Chris, also in his fifties, is a serious amateur who occasionally sells prints and who is frequently called upon to act as 'official' photographer at important local social events. He has only recently gone digital, but is an evangelical convert. His set-up gives an indication of the technological complex into which cameras – in his case a Canon SI IS prosumer (professional-consumer) compact – are sometimes inserted. The desktop PC is at the centre of a system with which the camera communicates via a collection of memory cards, a card reader, attendant cables etc. Chris sorts and stores his images on the PC, and works with two versions of Adobe Photoshop: Elements 2.2 and full version 7.0. He uses this software to make minor adjustments to his pictures, sometimes engaging in more advanced manipulation or reducing file size, before determining which path selected images follow next. There are several options. He prints a lot of pictures on his own Epson Stylus 1290, giving these to friends or adding them to his

portfolio with an eye to selling. He also stores and shares photos on CDs (with the help of a CD writer acquired for the purpose), and sends images over the Internet, usually as email attachments. Chris has yet to establish a web-based means of sharing, but it is on the cards. Occasionally, selected and edited photos go from the computer back on to the camera's memory card, as the camera has an audio-visual output which can be connected to a television for slide shows. In addition, Chris has a high-resolution scanner (originally an adjunct to his analogue SLR) with which he scans slides and old negatives. His camera fits into a spaghetti of cables and related devices all of which are integrated in the course of his various photographic performances.

Money allowing, individual practitioners have considerable discretion over the products they possess, and a common-sense conclusion would be that someone who just wants snaps will likely end up with a camera-phone, while someone who wants to do serious photography will have a more expensive and extensive kit of parts. But this is to miss the subtleties and in particular the dynamic of the processes through which performances of photography take shape and through which new people and materials are drawn into the practice.

Complex assemblies do not land ready made in a practitioner's home, and are only occasionally built from scratch around the camera. More often they emerge through a succession of acquisitions. Personal computers are not strictly essential for digital photography, but they are necessary for the satisfactory storage and retrieval of substantial collections of digital images. They also provide a necessary point of passage for images on their way to diverse means of display and sharing. Many respondents had computers and a range of related accessories (CD writers, Internet connections, printers, etc.) before acquiring a digital camera. The fact that a digital camera would fit into an existing network of already familiar equipment was often important in legitimating its purchase. With most of the infrastructure already in place, a digital camera added value, enabling the computer and its peripherals to be deployed to yet another end.

For others, the arrival of a digital camera disrupted rather than augmented the technological ecosystem of the home. Serious photographers who wanted to achieve high standards and to retain complete control over

the photographic process found that the typical home computer set-up could not cope with these demands. Members of the LCC repeatedly upgraded their computer systems to keep pace with the processor and memory requirements of successive versions of Photoshop, and with the possibilities afforded by higher-quality and often larger format printers.

In this as in other cases, relations between photographic performances and technological assemblies are characterized by dynamic processes and forms of feedback, none of which are adequately captured by concepts like those of domestication and configuration. Where performances, aspirations and technologies are in synch the result is one of provisional stability. In other situations, successive performances engender aspirations that prompt further development of the entire photo-technical complex. For individuals, mismatches of this kind may result in the acquisition of a new camera, better printer or faster computer. This can in turn provoke new rounds of escalating ambition as practitioners aspire to heights of photographic performance worthy of the technologies they now own – processes again comparable with the dynamic relation between having and doing described in Chapter 2. Accordingly, it makes sense to view photographic practice as a system defined by the constitutive elements of technology, competence and ambition, the co-evolution of which always results in provisional states of change or stasis. To understand more about how this works, we now turn our attention to the practicalities of actually doing digital photography.

DOING DIGITAL PHOTOGRAPHY

Getting a digital camera is one thing. Figuring out how and when to use it, and how and when to manage the images it produces, is another. In doing digital photography, new forms of competence, rationale and method are blended with existing habits and expectations. The detail of what this involves is of defining significance for the 'success' of digital, for individual careers and so for the future shape of photographic practice.

For most of those with whom we talked, the novelty of digital photography was diluted by prior experience with personal computing. Already

familiar with computers at home and at work, Chris had no trouble at all in managing the digital data generated by his new camera. Nor did he have any problem navigating the camera's menu system, or figuring out the basic rules of the game – for example, using combinations of buttons and arrows to select desired options. Other forms of spillover from previous photographic experience were also important, especially in framing ideas about what a camera was and what functions it ought to offer. For example, after some hours fiddling around trying to achieve what he knew he *should* be able to do, Donald finally resorted to the manual to discover where to find particular options and how to use them. As this experience indicates, the process of learning how to use a digital camera was typically one of learning how to persuade it to behave like the analogue model it had just replaced.

Reference back to previous experience was uniformly important, but having more or less got the hang of what a digital camera could do, respondents were immediately confronted by significantly new forms of photographic possibility. The capacity to click and delete, to post-process at will, and to take hundreds of shots for little or no cost is indeed liberating. These new-found freedoms were used in ways that represent an intriguing mixture of innovation and conservatism with respect to the types of images taken and to how they were manipulated, stored and managed.

Taking Digital Pictures

Donald and Louise's sister each exploited the potential to take hundreds of images in search of a conventionally 'good' result. Donald reported taking more than 250 photos of a particular species of garden bird in a single session,[2] experimenting with automated 'rapid-fire' image capture and then saving only one or two shots. According to Louise, her teenage sister spends hours at a time capturing stills of herself with a webcam, making subtle adjustments to position, framing, angle, lighting and expression, eventually arriving at an image good enough to send to her MSN buddies. Other more 'serious' photographers also enjoyed testing different techniques – composition, lighting, aperture, shutter speed, etc. – valuing the immediacy of the digital result and with it the rapid accumulation of 'photographic' knowledge.

The licence and liberation of digital photography was, in turn, relevant in extending the range of potentially photogenic situations and opportunities. Donald illustrated this point with a striking shot of Durham Cathedral taken in the first light of dawn. The challenging lighting, he said, would have prevented him from risking frames of film. In any event, he wouldn't have been out taking pictures at that time of day and certainly not on a freezing early spring morning. Donald's atmospheric image was only possible because digital photography had become so embedded in his life that he now carried the camera with him as a matter of course. His picture is therefore the outcome of a conjunction, not only of digital technology as such, but also of a redefined habit and a reinterpretation of risk.

The range of situations and circumstances in which cameras are available, and their capacity to capture and display images in an instant, is of collective and cumulative consequence for the boundaries and the meaning of amateur photography. To give a couple of other examples, digital cameras can be – and are – used not to take 'pictures' as such, but to take transient images, just for fun or capture visual data. Chris described how a crowd of students on a cartography field trip immediately reached for their camera-phones, using them to take a series of overlapping pictures to record the map on a roadside sign. Digital cameras can also be handed over to those who have yet to learn the conventions of 'normal' photography (Figure 9). Brian comments on this feature when talking about how his two children first got involved.

> They're now nine and eleven. So they were five and seven when we first got [the digital camera] and we were much more willing to let them use that than an analogue, because they can take pictures up their nostrils or whatever and it doesn't cost you anything. (Brian)

The fact that these novel or playful forms of picture taking were described as exceptional or innovative reinforces the point that the majority of those with whom we spoke routinely used their digital cameras to record a familiar repertoire of family events, holidays and social occasions, or to contribute to conventional genres like those of landscape, still life and portraiture. The miniaturization and diversity of camera-forms is nonetheless relevant

Figure 9 New recruits: children using digital cameras

for the situations in which they are used, particularly for the future of the images they produce. Opportunistic shots captured with a camera-phone were sometimes sent by SMS or by bluetooth to friends and class mates, but more often simply kept on the phone itself. By contrast, pictures taken with 'real' digital cameras were more likely to enter the image stream of domestic life and, as such, enter the substantially new field of home-processing and data management. This is a critical point: with digital photography, the various steps of taking, manipulating and keeping or discarding pictures are subject to rules and conventions of their own.

Manipulating Digital Pictures

The professionalization of processing, a critical breakthrough in the history of popular photography, has been severely hit by the arrival of digital. It is no

longer a case of pressing the button and leaving Eastman Kodak, or anyone else, to do the rest. While some amateurs, like John, are happy to delegate the digital equivalent of processing there are many for whom the capacity to manipulate and control their own pictures is a source of significant value and considerable 'photographic' satisfaction. This capacity also presents certain dilemmas, especially for the serious enthusiast (Grinter 2005). Members of the LCC talked of an experimental stage in which they explored the possibilities of photo-management software, pushing it to the limits by blatantly modifying and manipulating the pictures they had taken. Having got over this first phase, and having learned what they could do, individuals now spent hours using Photoshop not to transform, but to enhance digital images in line with the conventions of art photography. Their aim was to produce results similar to those which a skilled photographer could achieve in the dark room. For Donald, and for others like him, anything more than basic image optimization constituted a form of 'cheating'. That said, Donald was prepared to remove aesthetic as well as technical 'blemishes'. Another photo of Durham Cathedral, this time taken from across the river had, for instance, been improved by carefully removing a lifebuoy from the bottom right-hand corner. Although most of our respondents had access to some kind of photo-management software, few took advantage of its potential. Brian had a sense of what could be done, but as he explained, 'I don't really bother… I want, I take pictures of real things and I want them to look realistic, I suppose.'

The overall picture is therefore one in which complex networks of digital technologies and software are combined to produce effects that mimic the 'realistic' lack of freedom that is a defining feature of conventional film photography.

Organizing, Sharing and Viewing Digital Images

One important and distinctive feature of doing digital photography is that images can be treated in different ways. A vast number are deleted before being downloaded onto a computer and many more are discarded after a first viewing. But what of the rest? Digital images take up space on the computer, the camera or the camera-phone. In addition, they require some minimum level of organization if they are to be viewed effectively.

There are many possibilities for viewing digital images in relatively unscheduled ways, through web-based sharing, as desktop backgrounds or as randomly selected images on a screen-saver. Although only a few of our respondents were actively engaged in using (and thereby developing) websites like flickr, youtube, myspace or facebook, they were nonetheless obliged to develop new routines of viewing and storing the pictures they had taken. In talking about how they coped with these two features, respondents described personal, often idiosyncratic, methods of managing the pictures they had taken. For example, teenage camera-phone users described a sequence of deleting in which new but 'pointless' images were scrapped in order to preserve 'better' but older pictures, these generally being ones that had some kind of personal meaning. This method results in and requires a continual process of shuffling and evaluation, complemented by occasional downloading and archiving of images that have for one reason or another survived the test of time.

Other techniques replicated previously established habits like those of making and occasionally viewing a family album of favourite prints mounted and presented in some kind of order. Brian returned from a trip to Indonesia with a surfeit of digital images. In his words:

> lots of them were interesting and good but there were just too many to show to other members of the family, the typical sitting through other people's holiday photos – so I created another folder called 'best of Indonesia' and I've just taken maybe fifty, all decent photos … they also tell a bit of a story I suppose. (Brian)

Gordon's method has more in common with traditional strategies, like those of storing photo collections in something like a shoe box. His laptop includes many folders including one containing a hundred or so pictures taken on an outing to Pompeii. Although he has gone to the effort of turning these pictures the right way up, he has no intention of sifting the 'good' from the 'bad', of cropping or manipulating the images in any way, or of creating a more manageable album. Nor does he have any intention of producing prints. Single images sometimes make it to his printer, but only for some special purpose like that of being framed and hung on the wall.

Digital photographers make endless small decisions about how to handle the data they collect. These moves are now so intimately related to the doing of photography itself that they are effectively part of it, whilst also retaining a distinct status of their own. In technical terms, data – which is now an essential element in the materiality of amateur photography – flows seamlessly between multiple forms of storage, and between different formats, each associated with different grades of quality, file size and 'cost' – in terms of organization and time. Although respondents' data management strategies clearly related to established ideas about when and how pictures are to be shared and viewed, new questions arose. For example, are picture files to be classified by date, event or theme? Is there a folder for cats and landscapes, or should it be 'Summer 2006'? To complicate matters further, households are increasingly likely to own several cameras, and to adopt more than one mode of image management. The teenagers we interviewed were, for instance, building up personal photographic portfolios, scrapping and

Figure 10 Laptop photo albums

keeping pictures according to criteria of their own rather than with a view to documenting key moments, or contributing to the collective photographic record of family life. The work of fixing shared memories is evidently changed by the apparent democratization of home image making, and by the material forms involved.

Taking an album off the bookshelf is a different experience to that of plugging in a laptop, and although some are happy to 'flick' through digital files, others lament the passing of the printed form. Kodak advertisements plead with consumers to remember and cherish the feel and uses of a printed photograph, but it is already clear that if the classic family album is to survive in the digital era, it will require careful and deliberate construction of a new kind. Even the most conservative of our interviewees acknowledged that alternative genres of photographic order were taking shape as pictures circulated between friends and family members, and as personal and collective archives developed in parallel.

INNOVATIONS IN PHOTOGRAPHIC PRACTICE

The future of amateur digital imaging – and especially of viewing and album-making – is not at all clear: habits and conventions are being redefined 'on the run' as individuals design their own way through what is in effect a rather dense thicket of digital opportunity. Rather than being a random process, this is instead one framed and constrained by the spilling over of expertise from one domain to another and by the compulsion to reproduce certain already established conventions. Despite extensive potential for innovation, pathways through the digital photographic forest are already fairly well defined. This is in part because of the inevitably incremental nature of innovations in practice. The transition from film to CCD is technologically radical but in practice, and in becoming part of the fabric of everyday life, digital cameras (and related devices) are configured by and 'domesticated' into an already populated ecosystem of products, materials, norms, competences and meanings.

The arrival of the consumer-level digital camera set in train a dynamic process of disruption and development of which no single actor appears to

be in control. Established giants of the photographic industry are reorienting rapidly in response to changes wrought by the active appropriation of digital technology. While some elements of this system – especially artistic and familial conventions of worthwhile photography – are remarkably durable, others including the technicalities of image capture, manipulation and storage, are less so.

Figure 11 Dusty analogue camera

In grappling with digital technology, amateur photographers are actively involved in making links between new and existing elements. In so doing they are inevitably breaking previously critical connections from which popular film photography was formed. Initially expensive film cameras and photographic equipment can be bought for next to nothing on eBay, and darkrooms have been turned over to brightly lit computer studios with facilities for desktop publishing and printing. While this is a general trend, it is important to recognize that there are niches of persistence, and that the photographic field is in any case significantly and perhaps increasingly differentiated. A focus group with year twelve pupils suggested that film retained a place in their lives, not as the 'normal' form, but as one amongst a range of photographic modes. As they explained, digital cameras were carried and used to record classically photogenic events – holidays, parties and excursions. Camera-phones were used more spontaneously and were especially handy when the 'real' camera was not available. In between, there were occasions when neither fitted the bill, for example, because of the low quality of pictures taken with the phone, combined with the fear that the 'real' camera could be stolen or lost. In these situations a single-use film camera is still ideal. As this example suggests, the arrival and diversification of digital disrupts and reconfigures taxonomies of photographic opportunity, and associated concepts of quality and competence. In the context of the present discussion, the critical point is that these disturbances and reconfigurations are significant for individual photographic habits and so, cumulatively, for the practice as a whole. The detail and the direction of this reorganization depends upon both the scale at which new modes of image making take root, on exactly who is captured by different ways of doing digital, and in what circumstances previously faithful practitioners defect from film. We finish by commenting on our respondents' experience of becoming 'hooked' – or not – by film and by digital forms of amateur photography, and on the 'institutional' contexts and conditions in which these encounters are sustained.

Practices only exist if they are regularly reproduced and enacted, so how have film and digital photography recruited sufficiently committed practitioners and when and why do people defect? The experiences of Louise, Donald, Paul and Brian provide some clues.

Louise is seventeen and, like other teenagers with whom we spoke, her first experiences of photography were with the family camera which she was very occasionally allowed to use. Her grandfather gave her a camera of her own when she was about ten years old. This basic analogue compact saw limited use as she was unable to pay for film or processing and her parents were not keen to fund the habit either. Louise's first experience of digital photography was with a camera attachment to a Gameboy portable gaming console. The extremely low quality of images from the Gameboy made the process unrewarding and again Louise's interest lapsed. However, now that she has a Samsung camera-phone and rights to use the family's digital compact, she is taking more photographs than she has ever done before. The ready availability of these cameras slots into a generic tradition (taking pictures is something people do in this family), finally allowing Louise the chance to experiment and make this practice her own.

Donald, now is in his sixties, has a long-standing interest in photography. Starting with a Brownie 127 (which he modified to allow macro photography), he graduated to an Ilford Sportsman, before acquiring a Ricoh Single Lens Reflex (SLR). Over the years, he accumulated a set of lenses, a tripod and other accessories for the Ricoh, remaining faithful to it and to what became quite a serious hobby. Donald was initially dismissive of digital cameras, seeing them as a betrayal of the real photography in which he had invested so much. Despite his disapproval, Donald's wife bought herself a digital compact and some months later noticed that he was borrowing and using it rather more than he did his own SLR. After her camera was damaged during one of Donald's photographic expeditions, she made him buy one for himself. His Olympus C-765UZ, a four megapixel compact with ten times optical zoom, has revolutionized Donald's photographic career. Now liberated from the strictures of film, he is at last becoming the photographer he always wanted to be, making strides technically and aesthetically and producing images of a quality that had eluded him before. Donald's views on photography are defined and framed by his experience with analogue cameras, yet it was the digital technology that finally allowed him to master image making according to these ideals. This more complicated career is marked by moments of commitment, defection (from film) and new-found attraction (to digital). Across the years, skills and interests reinforce each

other in ways that are not at all uncommon and in ways that survive (but in newly reconfigured form) the transition to digital.

In looking back over his much more limited photographic career, Paul talks about why film photography failed to catch his attention or retain his interest. Although he had a camera, it was hardly ever used.

> It was a happy snapper, and I never really got round to using it. It might have been because when I got round to using it, I used so few pictures it took me forever to get through a roll of film, and then once I'd used the film up, it was such a rare event that I never got it developed, or it took forever to get it developed. So the whole thing, the whole concept of taking pictures, decreased and decreased and eventually evaporated. (Paul)

Somehow he never took quite enough pictures to cross the necessary threshold of routine use. The cost of film and processing was such that Paul thought twice about releasing the shutter: was the result going to be a picture worth paying for, and would it still be worth looking at months later when he finally got round to having it developed? The fewer pictures he took, the less likely he was to take more. Although Paul never became a film photographer, he is of the view that digital is much less demanding of those who do it. It requires certain resources – it means buying and carrying a camera, taking it out, taking pictures and then managing those small but necessary steps of downloading, organizing and sometimes printing, but for Paul and for Brian, the value of the results far outweigh these little costs.

Brian acquired a basic point and shoot camera when he was thirteen. Using it was enough to generate an interest in photography and, with it, a desire for a rather better model. At eighteen he bought a Russian-made Zenith SLR, teaching himself about the technical aspects of photography – aperture, shutter speed, focal length and so on – by reading books from the local library. Despite this initial enthusiasm, the expense of producing generally disappointing results was again such that the new camera soon fell out of use and was not replaced when it was lost only three years later. A series of compact analogue cameras, either borrowed or bought, served his limited photographic needs until 2003 when he acquired his first and only digital camera. The purchase was prompted by the need to take pictures in remote locations and in hot and humid conditions. Although acquired for

work, Brian's digital camera has been used extensively at home. All in all, its impact has been profound, embedding photography in Brian's life in a way the Zenith SLR never managed to achieve. As he explains:

> Since [getting the digital camera] I've used it for all sorts. It has completely changed how much photography I take because you don't have to worry about the cost of duff pictures or anything like that. And I use it all sorts of ways really.

In these last two cases, digital photography captures people where film had failed. Though the cost, especially of film and processing, is part of the reason why the 'ordinary' version never caught on, this does not explain how the digital version has worked its way into lives, habits and routines. Our respondents' accounts are not necessarily representative, but they do provide some insight into the conditions of photographic interest (if not enthusiasm) and into the circumstances in which the practice of taking pictures takes hold. They indicate that material availability matters, but that with film especially, the ability to practice, to persist and to learn is also critical. With limited use, cycles of competence and reward never take root and, as illustrated above, embryonic careers are easily shattered by failure. By comparison, digital offers faster forms of feedback and it seems that the process of 'becoming' a digital photographer is both more rapid and more rapidly gratifying. Taking a step back, all the careers described above indicate that amateur photography, broadly defined, is fit and well. Those with whom we spoke expected to take photographs whether of 'artistic' compositions or of themselves and others, and all placed some value on this capacity and on the ability to store and view the results. From this point of view, digital and film photography compete with each other within what is in effect a ready-made arena (Pantzar and Sundell-Nieminen 2003). Yet this is not a stable terrain for the arrival of digital technologies, and their varied but widespread appropriation in practice continues to reconfigure the field itself. Doing photography increasingly means doing things like taking, manipulating and sharing pictures. As these interpretations become established, film is literally edged out of the frame. Those who still carry on using it do so for special reasons, and not because this is the normal thing to do.

In reaching these conclusions, we underline three more general observations. First, the careers of individual practitioners matter for the trajectories of the practices they carry. Second, technologies do not only configure users – they also and perhaps more powerfully configure the practices into which consumers are drawn and from which they drop out. Third, and as we have also seen, digital technologies are not only or not simply 'domesticated' by different sorts of user. They were at the same time drawn into and defined by a framework of expectations and conventions established by an incumbent practice-as-entity: i.e. by various genres of popular film photography. By implication, the pathways and trajectories of future development are partly ready-made (by past experience) and partly shaped by the active integrative work of those who do amateur photography and who keep its various, always evolving, forms alive.

The Materials of Material Culture: Plastic

Figure 12 Plastic tea set

We have used cases and examples of kitchen renewal, DIY projects and digital photography to demonstrate different aspects of the relation between product and practice. In the process we have underlined the integrative work of consumption, and the active and constitutive part things and people play in configuring desires and competences and in reproducing and transforming social practice. In this chapter and the next we investigate the materiality of everyday life from slightly different points of view, first thinking about the substances of which things are made and then reviewing different ways of conceptualizing the values that are added by design.

This chapter concentrates on the relation between objects and materials[1] on the grounds that the consumption and production of consumer goods takes place within (and contributes to) what we might think of as material culture, broadly defined. In elaborating on this point, we consider the possibility and the potential of a social science not only of things, but also of substances. Having put the 'materials' back into the study of material culture, we go on to ask how 'value' is attached to products. In taking this approach, we turn our attention to the co-production of ideas and materials and the social organization of product design. This could be seen as a move from the world of consumption toward that of production and in a sense it is. On the other hand, and as will become clear in both these chapters, such a distinction simplifies and threatens to obscure precisely those mutually constitutive processes we seek to reveal.

Although we have been talking about stuff, including drills, kitchen units, freezers, cameras and radiators, we have rarely commented on the metals, plastics and timbers of which these things are made. The fact that this is not at all surprising is itself indicative of a taken-for-granted division of intellectual responsibility between the social and natural sciences. The grey area between molecular matter and cultural product is such unfamiliar territory that it is difficult to know quite where to begin, but in the light of the previous chapters and in the context of the book as a whole it is clear that some exploration is required. To go further in our analysis of the relation between product and practice we need to develop an account that somehow combines a discussion of the political economy of stuff (how do things come to be as they are, Molotch 2003) and material affordance (what do these things allow us to do) with a more cultural understanding of the

co-production of possibility. There are different ways of proceeding, but we choose to analyze this problem with reference to plastic.

The chapter starts with a discussion of plastic as an idea and as a vehicle for utopian visions of societal transformation. We then turn to the complicated relationship between material substances, specific objects and emergent concepts like those of 'property' and performance. This generates a range of further questions about the mass and matter of production and consumption, about how different products are configured from molecules and social symbolic reference points, and how such combinations are co-determined. First, some future fiction.

MATERIAL NARRATIVES

Yarsley and Couzen's now classic text, *Plastics*, ends with an imaginary account of the life of 'plastic man, a character who lives in the glorious plastic age of colour and bright shining surfaces' (1941: 154), and who is surrounded 'on every side by this tough, safe, clean material which human thought has created'. Plastic is to be found in the walls of his nursery, in the unbreakable, grease and dirt 'proof' windows of his school, in the silent, dustless floors of his home, in his plastic plumbing 'cemented together in a few moments', his warm pliable and clean armchairs, his beautiful transparent lampshades, in his golf clubs, in the car, boat or plane that he might use for travel, and in his office, where 'the very desks themselves will be made of this universal material'. As plastic man gets old, he will be wearing 'silent plastic teeth' and 'playing chess with moulded chessmen on a plastic board ... until at last he sinks into his grave hygienically enclosed in a plastic coffin' (1941: 158). All in all, his is a life lived in a world 'free from moth and rust and full of colour'. This fantastic story is as good a starting point as any from which to begin an investigation of tales and representations that define what are in turn mutually constitutive relations between material substances and objects or products.

In *The Gift of Stones*, Jim Crace (1988) writes about what one would have to call the 'material culture' of stone-age society. In Crace's novel, the collapse of a way of life organized around specialist skills in knapping flint

and trading implements and tools of stone is symbolized by the dramatic and traumatic arrival of a bronze arrowhead into someone's chest.[2] The so-called 'three age system' of stone, bronze and iron was developed by Thomsen, an archaeologist charged with the task of organizing the Danish national archive in the mid-nineteenth century. Thomsen came up with this scheme in response to the problem of quite literally sorting things out, and of constructing and detecting diachronic and synchronic patterns in an otherwise disordered collection of artefacts (Bowker and Starr 1999). Like all such schemes it prioritizes specific threads of continuity and disjunction, and as such reproduces a distinctive, if tacit, account of social change. In representations of this kind, the materials of social life are self-evidently important, as they are for disciplines that gather under the heading of material science or that deal with the social and economic impact of unequal access to minerals and other natural resources. While natural scientists address the material world head on, the social sciences – including those which specialize in the study of science, technology and material culture – are generally more cautious, for good if slightly different reasons.

Daniel Miller contends that society constitutes an always 'cultural project in which we come to be ourselves in our humanity through the medium of things' (1998a: 167). Like others who write about material culture, he focuses on *things*, not on material substances as such.[3] The empirical task of analyzing the lives of materially composite but socially and culturally integrated objects is consistent with the theoretical project of addressing fundamental questions about the circulation of symbolic meaning, the reproduction of social order and the dynamics of appropriation and consumption. If the job is to understand the 'concrete means by which the contradictions held within general concepts such as the domestic or the global are in practice resolved in everyday life' (Miller 1998a: 19) or to show that 'consumption goods are more than mere packets of neutral 'utility' (Gell 1986: 110), then it is the symbolic positioning of objects that matters. In underlining the irredeemably social status of things, in demonstrating their 'interpretive flexibility' and in describing the situations and circumstances in which meanings and values are attached and modified, people working within these traditions are understandably wary of analyzing the matter of material culture.

There is no obvious rationale for attending to collections of artefacts just because they happen to be made of the same stuff. In fact to do so is positively suspect, carrying with it the risk of reproducing unfashionable and arbitrary modes of functionalist reasoning, or of implying that the meaning of an object is somehow fixed by its form and substance (Dant 2005). One somewhat ironic consequence is that theories of material culture have very little to say about stone, plastic, aluminium or steel.

Although also suspicious of the determinism implied in talk of 'ages' like those of iron or information, sociologists of technology are not quite so averse to the study of material culture. We will never know what images and future visions guided the metallurgists whose efforts underpinned the 'bronze age', but one thing is for sure: materials like these do not exist outside society. They are not 'just there' waiting to be exploited, discovered and appropriated. In materials science, as in other areas of scientific endeavour, lines of enquiry and pathways of innovation are nudged this way and that by socially and historically specific patterns of investment, interest and enthusiasm. The properties and characteristics of man-made materials consequently reflect and embody characteristics both of the culture in which they were made and of an imagined future in which they might be used. These observations are consistent with much that has been written about the social shaping of technology and about the 'promise requirement cycles' through which hopes and expectations are given shape and form. Within science and technology studies, materials constitute one amongst other technical systems all of which are subject to forms of sociotechnical co-evolution. Figuring out exactly how these dynamics unfold is a legitimate and interesting task in its own right and one that has generated material narratives of at least two types. Kipling's *Just So Stories* have their parallels in histories of technology: how the leopard got its spots, how the refrigerator got its hum (Cowan 1985) and how Bakelite came to be as it did (Bijker 1995). The retrospective retelling of technological trajectories frequently reveals the critical role of prospective narratives within and as an integral part of the innovation process. As Rip and van Lente (1998) have shown, scientists' projections about potential benefits harden into requirements and targets to be achieved when funding is in place. Promise making and story telling therefore constitute important mechanisms through which

expectations 'get articulated, become available as part of a repertoire, and become embodied' (Rip 2005). More generally it is through processes like these that imaginary versions and visions of future society are folded back into the work of the present, as a result of which technological (and material) trajectories come to be as they are.

Whether the emphasis is on the past or the future, there is a tendency to treat materials as relatively bounded 'technologies' or technological fields, each with their own narratives of invention, diffusion and application. Bijker, for instance, explains that his detailed analysis of the social construction of technology is 'primarily concerned with the development of one artefact such as the safety bicycle or Bakelite' (1997: 194). Ironically, the symbolic careers of things and objects – so central to theories of material culture – barely make an appearance in studies of material innovation. This is a curious omission given that materials are routinely known, encountered and understood, not in the abstract but in and through the 'materialized' form of specific artefacts.

Given the discussion above, the primary purpose of this chapter is to examine material narratives that run *between* material substances and objects or things. This exercise demonstrates the relevance and potential of a more thoroughly material approach to the study of material culture and of a more thoroughly materialized analysis of objects. Specifically, it suggests that the relation between materials and objects is co-constitutive and dynamic, and that it can and should be the subject of systematic social enquiry. We elaborate on these ideas by looking at three aspects of the material-object relation, starting with a discussion of how visionary and utopian ideas guide and are guided by specific instances of 'materialization'. The next step is to show how new classes of materials are positioned with respect to existing taxonomies of performance and product, and how relational schemes of meaning unfold over time. The third is to focus on the synchronic relation between apparently discrete objects and to show how these patterns also have a bearing on longer-term narratives of material and object development.

Plastic is both a good and a difficult case with which to work. It is good in that it has a relatively short history; it has had to establish a place for itself in relation to what Manzini (1992) calls 'archaic' materials, it

has arguably transformed the world of goods and its status is subject to continual negotiation. On the other hand, the fact that plastic is not one substance is potentially complicating. In what follows we are sometimes relatively precise, for example, distinguishing between thermosetting plastics, like melamine, (that do not re-soften when heated) and thermoplastics, like polythene, (that do) but for much of the discussion we use 'plastic' as shorthand to describe a multitude of 'polymeric materials' the physical properties of which are enormously diverse. We also refer to examples of pre-synthetic and synthetic plastics rather randomly, sometimes taking them out of chronological sequence. For the record, approximate dates of 'invention' are as follows: Parkesine (1862), Bakelite (1907) polyethelene (1933) acrylic (1936) and melamine (mid-1930s).

This approach makes sense in that the ambition is not to contribute to the social history of plastic, of which good accounts already exist (Friedel 1983; Sparke 1990; Meikle 1997), to critiques of its environmental impact (Manzini 1992) or to close investigation of particular products (Clarke 1999). Instead, the goal is to illustrate the sociological significance of materials and to do so by analysing plastic as a synthetic combination of molecules *and* social-symbolic reference points. One further word of caution is in order. In reality, consumer goods typically consist of multiple components that are themselves complex composites. In discussing Parkesine combs, polyethelene washing-up bowls and melamine tableware we pick on simple examples made from a handful of relatively uniform materials. This restrictive strategy allows us to focus on key aspects of the material-object relation, but it does not mean these are the only dimensions that matter or that the processes we describe count with equal weight for everything that is made of plastic.

THE PROMISE REQUIREMENT CYCLES OF MATERIAL CULTURE

Geels and Smit conclude that optimism is an essential ingredient in technological innovation, especially in the early stages.

The reason that initial promises and expectations are too optimistic is not that forecasters or futurists are ignorant or short sighted. Instead, the promises are strategic resources in promise-requirement cycles. Initial promises are set high in order to attract attention from (financial) sponsors, to stimulate agenda-setting processes (both technical and political) and to build 'protected spaces'. (Geels and Smit 2000: 881–2)

The following extract from a short film entitled the *Kingdom of Plastics* produced by the Handy Jam Organization in 1945 is equally explicit about the driving role of future visions:

The future will bring plastic fabrics wonderfully resistant to wear and stains and to the hazards of washing, shoes more glamorous than Cinderella's, but that is not all: there will be furniture combining strength with lightness, comfort with eye appeal, homes throughout will be bright with colour … this is a dream of the future yet out of such dreams has come all that we call progress so in the years ahead, dreams like this and many more will become realities. (Handy Jam Organization 1945)

Writing of aluminium rather than plastic, Schatzberg describes the remarkably similar aspirations of 'Nonprofessionals, scientists, engineers, and industrialists' who 'waxed poetic about the metal's contributions to the progress of civilization' (Schatzberg 2003: 226). These images and ideas acquired social power as more people and as different types of people fell under their spell. As anticipation travelled back and forth between the laboratory and popular discourse, promises acquired tangible, material form. In the process, it became clear that the progress of civilization depended not on aluminium as such but on the properties and qualities of things (including new things) that could be made of it.

In speaking 'glowingly of a future in which plastic and other synthetic materials would revolutionize American life' (Corn and Horrigan 1996: 82), prophets simultaneously imagined a new world of goods in which housewives would melt once-used dishes and stockings and wash down the plastic interior of their home with a hose. Monsanto's plastic house of the future, set up in Disneyland in 1957 and demolished ten years later, constructed, reinforced and embodied concepts of what plastic was and

what it might be good for. In the first year of opening, around 60,000 visitors a day were informed that: 'The floors on which you are walking, the gently sloping walls around you, and even the ceilings are made of plastics' (Yesterland 2006). Amongst other qualities, much was made of the fact that the house was durable, waterproof and impervious to rot. Further claims were made about plastic's 'warmth', 'charm' and aesthetic 'beauty' (Kissell 2005).

As these examples suggest, thoroughly positive images – circulating from the 1940s through to the early 1960s – cumulatively defined an imaginary space of modernity and scientific progress into which plastic products were located. The key point here is that future oriented promises have a vital role in materializing and making real otherwise rather abstract concepts of potential and in configuring and positioning ranges of imaginary products in markets that have yet to develop. In short, cycles of promise and requirement extend beyond the realm of scientific research and development, and spill over into the business of making products, markets and consumer expectations. This is not news. But it is interesting and perhaps important to reflect on the relation between generic technological narratives and specific forms of product-related promise. The next section explores the proposition that specific instances of materialization are cumulatively significant for the redefinition and ongoing transformation of generic material identities.

In material science, performance is a technical term that describes how substances respond to changing conditions of heat, light, stress and so forth. In everyday language, objects perform well when they live up to expectations and meet the criteria expected of them. In the following paragraphs we suggest that materials and objects are actively, if differently, implicated in configuring both these concepts. Put simply, specific products are as important in shaping the image of plastic (including interpretations of its properties and definitions of performance) as this image is in shaping ideas about potential areas of use and application.

PROPERTIES AND PERFORMANCES

Early uses of Parkesine illustrate relevant aspects of the symbolic interaction between materials and objects. Parkesine, a mouldable material made by

dissolving cellulose in nitric acid, was created by Alexander Parkes and exhibited at the Great International Exhibition in London in 1862. Objects included in the show exemplified the 'numerous purposes for which it [Parkesine] may be applied, such as Medallions, Salvers, Hollow Ware, Tubes, Combs, Knife Handles, Pierced and Fret Work, Inlaid Work, Bookbinding, Card Cases, Boxes, Pens, Penholders, &c.,'. This otherwise unrelated assortment of artefacts was designed to demonstrate the distinctive qualities of the stuff itself. As the catalogue goes on to explain, Parkesine

> can be made Hard as Ivory, Transparent or Opaque, of any degree of Flexibility, and is also Waterproof; may be of most Brilliant Colours, can be used in the Solid, Plastic or Fluid State, may be worked in Dies and Pressure, as Metals, may be Cast or used as a Coating to a great variety of substances; can be spread or worked in a similar manner to India Rubber, and has stood exposure to the atmosphere for years without change or decomposition. (Anon 1862)

The Parkesine exhibit is revealing on a number of counts. First, and most obviously, Parkes displays finished artefacts – not the 'raw' material itself. It is only through these objects that he is able to make real the otherwise invisible properties of his invention and to literally show its mouldability, its potential for colour and its flexibility. Second, items like the comb have the dual effect of positioning Parkesine in relation to bone or tortoiseshell *and* of changing what people expect a comb to be. In modifying concepts of performance associated with familiar and established objects new materials 'overtake' the substances they substitute and provide a focus for fresh product-specific interpretations of value and quality. Parkesine consequently set new standards for the comb-making business at large.

Third, the Parkesine exhibit shows that in moving from production and invention to application(s), material promises and possibilities proliferate, fragment and multiply. Parkesine has multiple coexisting incarnations – as medallion, as comb, as card case or pen – and therefore more identities than would be imaginable for any one bounded artefact. Exactly how these combine and with what cumulative consequence depends upon the range of end-uses involved. The social meaning and status of aluminium has been shaped by its role in different cultural settings: in air-craft manufacture (in

which it was associated with glamour and modernity), in making kitchen pots and pans (through which it acquired connotations of ordinary utility) and for a period in domestic wiring, a context in which it was a serious fire hazard and as such associated with risk and danger (Schatzberg 2003).

The search for substitutes that are cheaper or in some way superior to the materials they replace provides an important explanation for investment in innovation and for the direction this takes (Friedel 1983; Sparke 1990; Meikle 1997). One result is that material identities are frequently defined in relation to rival or incumbent substances. For example, billiard balls of celluloid, first produced in 1865, were immediately compared with those of ivory. Although ivory was becoming increasingly expensive, it retained the advantage of not exploding – as the celluloid alternative was prone to do.

The argument that 'technological framing' (Bijker 1997) influenced the terms and processes through which the qualities of materials like Bakelite were defined and specified is convincing enough, but in treating Bakelite as a *technology*, and as an *artefact* in its own right, Bijker fails to investigate the framing and comparative positioning of the many different objects into which – and in a sense of which – it was made. Since Bakelite was advertised as 'The Material of a Thousand Uses' (Bijker 1997: 182), the salience or irrelevance of specific characteristics varied depending on the use in question and on the other material or materials with which it was compared. If we attend to contexts of application and use, rather than invention or production, it is immediately apparent that far from being defined by 'one' technological frame, the material-in-use enters multiple arenas, finding its way into all manner of markets, industries and socio-technical situations. In each it occupies a distinctive position the details of which depend upon the object-specific 'framing' of qualities and on object-specific judgements about the relative merits of new and existing materials.

Beyond the laboratory, Bakelite was therefore defined by endless over-lapping webs of relational performance, 'beating' existing products on some counts and failing on others. This leads not to the simplistic conclusion that new materials succeed when they outperform their rivals, but to new areas of enquiry about how concepts of performance themselves evolve and take hold in the conceptual space between generic materials, on the one hand, and particular applications on the other.

With plastics as with aluminium, the process of 'finding' application —
and of thereby acquiring connotations and identities — is highly contingent,
reflecting specific social, economic and institutional conditions, shortages of
other materials, and chance encounters between individuals, institutions and
industrial sectors. In illustrating this point, Miekle describes how companies
switched from one product area to another, moving from aircraft parts to car
tail lights and roadside signs as they developed (and chased) new techniques
of colouring and of making and moulding acrylic sheeting (Meikle 1997:
186). As the commercial trajectory of acrylic indicates, contexts of applica-
tion are subject to change as rival materials arrive on the scene, as entire
product lines appear and disappear, and as socio-technical systems co-evolve.
These are, of course, processes in which materials and associated structures
of expertise are themselves implicated. Electrical engineers, familiar with the
insulating properties of Bakelite components, were apparently instrumental
in putting it to use in a variety of other roles, including 'steering wheels,
door handles, instrument panels, magneto couplings, timing gears, heaters,
gearshift knobs and radiator caps' (Bijker 1997: 175). For a while, Bakelite
dominated the form and fabric of a range of goods including radios,
hairdryers and telephones, simultaneously demonstrating and exemplifying
new aesthetic and economic properties like those of streamlined moulding.
As the relationship deepened, items were designed to suit the material of
which they were made (Meikle 1997: 116). But only for a while.

The many concepts of performance of which a material is composed – and
to which it contributes – are relative, provisional and inherently precarious.
This is in part because novel substances forge and fracture relationships
between existing materials, and in so doing disrupt the taxonomies and the
symbolic and practical repertoires which define and constitute the wider
'culture' of materials. In the next section we elaborate further on this aspect
of material-object relations.

MATERIAL-OBJECT RELATIONS

The year 1948 was a momentous one for washing up. Tom Merriman
describes this 'Quiet Revolution' in a brief article published in the

Plastiquarian (Merriman 1991). It all began when Halex (a plastics company) took delivery of a moulding machine bought to manufacture cellulose acetate toilet seats. The tools for making the toilet seats had yet to arrive so Merriman and colleagues looked around for something else with which to test the new machine. They 'unearthed' and modified a 'pre-war experimental tool for compression moulding washing-up bowls'. For material they stripped and ground up the polyethylene insulation from a roll of war-surplus cable. The result was a heavy washing-up bowl the colour of dirty candle wax. Since the only aim was to test the machine, the bowls were reground and moulded again as soon as they had cooled. At the end of a day of testing, one employee took home a complete but very dirty bowl. Merriman takes up the story:

> The following morning, Jack came in full of enthusiasm for his new bowl. Washing-up was suddenly quiet, without the scratch and scrape of enamel against plates and cutlery ... more scrap was found and, with a little mottling colour added they went very well at 5s each – so well, in fact, that within a few days it was clear that some people were buying sufficient to supply retailers around Highams Park! (Merriman 1991: 13)

Soon selling for 25 shillings each (the equivalent of about £30 today) there was instant demand for bowls that were silent and virtually indestructible. This latter feature was graphically illustrated when the company hired a London bus 'to be photographed running over the "unbreakable" bowl which then regained its shape' (Merriman 1991: 13). Identical qualities are highlighted in an advertisement for ICI 'Alkathene' washing-up bowls featured in *Ideal Home* (1957a) a decade later. The text of the advertisement runs as follows:

> Like you, she couldn't help knocking plates and glasses against the edge of the bowl. This meant cracked and chipped things and the expense of replacing them. So she bought a new bright bowl made of 'Alkathene', the ICI polythene that does not harm crockery and cuts out that annoying clatter.

The arrival of the plastic washing-up bowl arguably transformed both the practice of doing the dishes and the material identities of enamel

and ceramic. Suddenly, washing up without one became associated with an annoying clatter. Likewise, only a polythene bowl could provide an appropriate 'cushion for your crocks' (Ideal Home 1956a). In the same move, enamel acquired undesirable characteristics: causing chips, scrapes, cracks, scratches and problems that no one had noticed before.

Other everyday objects turned out to have similar defects with the result that a plastic bucket could be applauded for being 'noiseless in use ... its soft feeling surface cannot scratch' (Ideal Home 1956b); and a Bex bin could be described as

> a refuse bin that refuses to get chipped, cracked, rusted or broken. No irritating clanking noises, no hesitation about the opening mechanism... It is made from polythene so it is not only virtually unbreakable, but really nice to look at (Ideal Home 1956c).

These examples illustrate the more general point that material taxonomies are inherently dynamic. The characteristics of enamel and of plastic are defined in relation to each other. The appearance of alkathene is consequently important both for this interaction *and* for existing relations between washing-up bowls and crockery. In other words, new substances transform the relative standing of incumbent materials with sometimes 'revolutionary' consequences for manufacturing, production and practice. Features like those of silence, unbreakability and colour are realized and made real in the form of specific artifacts, and through object-to-object comparisons. We have already noticed that new substances enter the relational fabric of material culture at many points depending upon exactly what they are made into and how they are materialized. The further observation is that at any one of these points they are likely to engage with multiple dimensions of performance, as illustrated by the following catalogue of interrelated qualities of melamine tableware:

> Dishes made of 'Melmex' melamine resist breaking chipping, cracking. They last ages. They're hard, smooth, solid. They have circus-bright colours or cool confetti pastels. They have lovely, ultra-modern shapes. Some go travelling in boats and caravans; some stay at home serving meals with a new kind of elegance. 'Melmex' is starred in the best run homes these days. 'Melmex' is for you. (Ideal Home 1962)

The accompanying picture of a seal juggling a set of plates and cups under-lines their unbreakability, a feature also illustrated in a 1953 advertisement in which two plates are dropped eighty-five times from a height of 8 feet onto a hardwood surface (Goldberg 1995: 138).[4]

As the Alkathene and Melmex advertisements hint at, and as others make clear, companies sought to make new markets and meanings by exploiting specific features of the object-material relation. Formica and Wareite laminate work surfaces and table tops were promoted as being *simultaneously* heat resistant, not subject to rusting or warping, coloured, patterned, durable, hygienic, washable, unscuffable, unsplinterable and labour saving. As such they were 'better' than a range of possible rivals including wood, metal and marble. This kind of multiple referencing is important in defining new formulations of material and product, in locating them in existing markets and in creating completely new terms of comparison, value and exchange.

So far, we have considered the material positioning of relatively isolated objects: plastic washing-up bowls, melamine plates and Formica worktops. We have also focused, at least implicitly, on the chronological development of material-object identities, noticing how enamel became noisy and how timber became unhygienic when faced with an influx of plastics. It is, however, important to highlight the synchronic dimension of material-object interaction. Many forms of plastic and plastic-based products flooded into British homes and into the evaluative taxonomies of material culture at around the same time. The immediate post-war period was therefore one in which combinations of material innovation had cumulative implications for ideas about quality, design, style and modernity, and for generic expectations about the colour and form of ordinary household goods. In commenting on these two themes – first colour and then design – we suggest that analysis of relations between artefacts opens up new lines of material cultural enquiry and generates new questions about the emergent consequences of material and cultural transformation in relation to the design of everyday life.

The Chromatic Revolution

The very concept of a coloured, let alone matching bathroom suite or set of household brushes supposes and requires a measure of coordination

between chemistry and culture. It is difficult to pin down the exact chro-
nology of what Blaszczyk (2000) and Meikle (1979: 15) refer to as the
'chromatic revolution': it seems that it varies between countries and that
it is 'carried' by different goods – ceramics being a critical vector in the
1920s and 1930s, followed by plastics in the 1940s and 1950s. In the
USA in the 1920s, colours apparently 'gripped the home furnishing trade
following the introduction of new pigments, lacquers, and dyes by the
American chemical industry' (1979: 146). In the UK, Yarsley and Couzens
report that 'the equipment in our daily life has, in recent years, taken on
a brighter and more attractive appearance' (1943: 4). A systematic review
of *Good Housekeeping* and *Ideal Home* from 1922 to 2002 (Hand and Shove
2004) reveals persistent and explicit reference to colour in mid-1950s
advertisements for blankets, Velux extractors, tableware, kitchen surfaces,
flooring, washing-up bowls and more. These representations demonstrate
both the diffusion and popularization of what were described as bright
gay colours. For example, a 1956 advertisement for AZTEC 'breakproof'
dishes, invites the housewife to

> picture the warm, glowing tones of AZTEC at your table! Happy colors that
> add to the enjoyment of every meal. Use it in single colors or mix them for a
> beautiful rainbow effect that makes the table sing with color (Vardin Sales Corp
> 1956).

A matching set of six brushes and a bowl available in either red, green,
blue or yellow is described as 'the Addis gift set for the colour conscious
bride', available for £3 3s or around £50 in 2004 prices[5] (Ideal Home
1957b). And perhaps most pervasive of all, decorative laminates, one of
the primary materials by which plastics 'made an impression on the general
post-war public' (Meikle 1993: 11) are billed as demonstrating 'new
scope for colour'; generating previously unprecedented opportunities for
planning with a 'fresh, completely *different* range of colours and designs' and
constituting a material which in 'all its enchanting variety can bring new
colour into your home' (Ideal Home 1959).

Entire families of materials carried and were caught up with ideas and
images about interior décor and the importance of colour in the modern
home. Synthetic textiles, ceramic, enamel and plastic all contributed to

this mutually reinforcing 'trend', each material helping to define colour as territory on which all might compete. However, once the importance of colour was established, within any one home, questions of stylistic order had to do with the relation not between generic materials but between discrete artefacts like the brush, bowl, work surface and waste-bin. Plastics and plastic products contributed to the colouring of everyday life and to a regime of manufacturing and marketing in which the capacity to be colourful was an important attraction and an increasingly necessary condition. But it was not a defining feature of plastic alone, and not one on which its image ultimately depended. As this brief discussion suggests, materials and related innovations in product design can reinforce emerging patterns in the culture of materials. At the same time, 'materials' – being made into many objects – have multiple dimensions and performative relations: they are culturally extended and, because of this, their identity is consequently difficult to control.

Design and Image

When the objects on which plastic's reputation depended fail to live up to expectations, or when low-quality or poorly designed items were made of plastic, the standing of the entire industry is put at risk. At least, this is how it seemed for companies involved in the UK plastics industry in the 1950s, and earlier in the USA. Since 'consumers relate particular ideas to plastics which are implicated in their attitudes to plastic objects' (Fisher 2004: 29), careful management of the material-object relation was vital, particularly given plastic's potential to mimic other 'real' materials. In both countries, industrial product designers were enlisted in a deliberate effort to make stylish and valued goods, and through that to cultivate a positive and distinctive image for plastic as a whole.

Meikle, writing about the USA, explains that 'Plastics and industrial design enjoyed a symbiotic relationship' (1979: 80) in which designers mediated between object and material with the aim of setting in train a mutually reinforcing cycle of status and credibility. Positioned as magicians of image, 'always involv[ing] a dialectic process between ideas and matter' (Manzini 1992: 2), the designer's task was to generate concepts and products through which plastic would be valued as a material that had indeed come into its own.

In the UK, British Industrial Plastics set up a free design and advisory service for manufacturers in an effort to increase the use of Melmex, and influence the style and quality of products made from it (Akhurst 2004). This service was led by 'Woody' Woodfull, whose brief was to 'bring art to an artless industry' (Plastiquarian 2005: 10). In deliberately exploiting new possibilities of colour and 'modern' shape, Woodfull's own work for the Gaydon brand appeared to do the trick, as indicated by a review in *Design*: 'Encore, designed by A.H. Woodfull for BIP Gaydon Ltd, should remove the last vestiges of prejudice against the use of plastics for tableware. The clean, plain shapes and subtle colours make the range elegant enough for even the most fastidious diner' (Design 1966: 58). Woodfull's team included David Harman Powell, designer of a stylish set of brightly coloured tableware for Ranton and Co., and of Ekco's Nova range which won the Duke of Edinburgh's prize for elegant design, and received special commendation for using plastic 'as a material in its own right and not as a substitute for the traditional ceramic' (Design 1968: 27).

In the longer run, efforts to stabilize the status of plastic and bring it within the fold of desirable and respectable elegance were relatively short lived. Akhurst (2004), who follows the 'rise and fall' of melamine tableware, tries to account for its rapidly declining popularity during the 1960s. He suggests that white-lined cups, which made the tea look 'right' also 'showed up all the staining and scratches for which melamine ware became infamous'. This observation is surely relevant, but it is not enough to explain why melamine is currently reserved for picnics, children and collectors of vintage plastic or for that matter why consumers are reportedly suspicious of storing food in Tupperware containers. Tom Fisher's study of contemporary cultural interpretations and 'folk knowledges' points to other objections, including associations with 'negative, possibly disgusting, sensorial experience which is invoked in the use of "tacky" in all its senses: cultural, structural, and sensorial' (2004: 24). In the words of one of Fisher's interviewees: 'I think Tupperware tends to be a bit smelly […] I think it retains its smell after you take the stuff out' (2004: 28). This hesitation, which is a far cry from the excitement generated by the Tupperware parties that Clarke (1999) describes, provides a telling reminder of the precarious nature of meaning, association and affordance. Fisher makes this point explicit: 'affordances

cannot simply be "built into" or "read out of" artefacts, but are discovered by users through interaction with them' (Fisher 2004: 26). It is, of course, important to recognize that the switch from esteem to contempt is not entirely accidental. In writing about the political economy of polyester, and about the substantial commercial interests involved, Jean Schneider explains first the desire and then the disdain for polyester in terms of 'the interaction of consumption and production and of socially changing, value creating consumers with competing, predatory industries' (Schneider 1994: 3).

This ongoing interaction guarantees the fragility of the cultural-material taxonomies referred to earlier. As the relation to ceramic crockery turns full circle, plastics that were previously valued for being silent, hygienic and 'soft to the touch', are redefined as tacky, unbreathable and impossible to clean. Meanwhile, new associations like those between melamine, childhood and outdoor activity have emerged as the link with elegant dining falls away. All this suggests a kind of symbolic circuitry in which generic interpretations (for example, of plastic) unfold through material-object relations, in which the status of individual artefacts is shaped both by this relation and by consumer-object interactions, and in which these interactions successively and in combination reconfigure generic material identities.

The basic narrative structure is one in which objects 'tell tales' about materials and in which material discourses influence repertoires of positional storytelling in and through which objects acquire (and lose) aspects of symbolic meaning. Since manufacturers and designers deal with only a limited part of this system, deliberate efforts to control and contain the image of plastic are probably doomed to failure. This is partly because plastic continues to take many forms, each being materialized and realized in quite different ranges and types of product. Within the synthetic field, manufacturers have sought to carve up an otherwise culturally undifferentiated territory, using brand names to define and distinguish nylon from lycra, polyester, orlon, dacron, crimplene, terrylene, tricel, courtelle, wincyette and dralon, to name but a few.[6] This may help in managing the reputational risks alluded to above but companies aspiring to make 'high-quality' plastic goods can do little to curtail the cultural damage engendered by the proliferation of artificial plastic foliage, or by the material's association with cheap copies and a flood of increasingly disposable products from around the

world. Nor can they prevent rearguard actions initiated by industries and trade associations threatened by an influx of synthetic materials. To quote Schneider again, the fibre war between synthetic and natural materials was (and is) fought out as much between competing manufacturers as between producers and consumers (Schneider 1994: 3).

THE MASS OF PRODUCTION AND CONSUMPTION

It may be impossible to defend the reputation of plastics and other synthetic materials, but as Handley's excellent discussion of Nylon (1999) makes clear, the very concept of owning an entire wardrobe of clothes owes much to the ready availability of stuff like nylon, polyester and acrylic. In demonstrating that wardrobes are not the inevitable outcome of a one-way flow of technological determinism, Handley engages with critical questions about how new materially mediated relations of production and consumption take hold. Having taken hold, they generate a form of cultural and material irreversibility: now that we are used to having a choice of what to wear, it is almost impossible to imagine any other arrangement. And in so far as the present state of affairs depends upon a steady supply of synthetic fabrics, we might reasonably conclude that these materials are set to retain their grip on material culture at large.

Manzini (1992) addresses similar themes when writing about how the mass of consumption is quite literally related to the mass of production. Like Dant (2005) he identifies general trends and concludes that people are interacting with an increasing number of goods the design and production of which reflects ever more complex, ever more distanciated forms of 'material-sociality'. Manzini attributes this to a trajectory of innovation in which the previously limiting role of matter is overcome and in which the potential to produce complex shapes, forms and textures is so extensive that plastics now represent materials of almost unlimited invention.

Most of this chapter has been concerned with the processes of mutual governance that characterize the relation between objects and materials. Yet there are cases in which material and object are one and the same, and in which there is no difference in the representational positioning of the two. Close-coupled instances of material-as-object lie at one extreme of a

spectrum of possible formulations defined, at the other end, by situations in which millions of different objects are made of 'the same' material. Where things lie along this scale of possibilities reflects and constitutes their positioning in the political and economic world of production.

As indicated in the following extract from a 1961 speech by David Dawson, of Du Pont, the business of making markets for plastic involves constant movement up and down the supply chain, and between densely clustered or distributed sites of innovation and production. These movements constitute a form of connective tissue linking the economic geography of the material to that of the object, and sometimes doing so to the extent that the distinction between them blurs. Dawson talks about how the laboratory based design of plastic relates to the market for specific components.

> Much of the work in these laboratories is directed toward the cultivation of markets once or twice removed from our own ... In plastics, especially the newer types, it is often necessary to work out design of a plastic component for use in an automobile or a washing machine and only then go to work with our immediate customer, the supplier of moulded or extruded parts, on methods of producing the parts. (Backman 1965: 44)

Connections between organizations involved in plastics technology and in the development of specific applications for cars, domestic appliances, etc. define sub-structures of production and consumption that are cumulatively important in configuring pathways of material *and* artefactual innovation. The economic geography of plastic production and of plastic-related expertise is immensely complex. In representing these relations, Streb (2003) and Patrucco (2005) describe dense, overlapping skills in material science, fabrication and design, combinations of which are fluidly organized within and between companies that are forever clustering, fragmenting, merging and spinning off. Taking a broader view, Streb argues that local, national and international systems of inter- and intra-industry knowledge exchange between chemical companies, those making fabricating machines and those producing finished products have proved important in addressing common challenges of plastic production (e.g. issues of injection moulding) and application (e.g. how to use plastics to solve specific problems), and in creating new areas of specialist knowledge. There is obviously more that

could be said but rather than going deeper into the power structure of the plastics industry, or into the relations between this sector and the world of metals, alloys and composites, these few paragraphs are sufficient to demonstrate that there are further points of connection between the cultural, political and economic trajectories of materials and object(s), and that these are again relevant for the identities of both. Schneider (1994) completes the circuit with the suggestion that macro-economic developments in the world of mass production, including the production of synthetic materials, are of consequence for consumer incomes and for the fabric of social order. It is into this world that the material results of mass production circulate and acquire symbolic and cultural meaning. Such meanings and images – like those of the tackiness or the allure of plastic – are made and reproduced through processes of consumption that are, in turn, relevant for the future of what is and what is not produced.

THE SOCIAL LIFE OF MATERIALS

The conclusion that prospective and retrospective narratives of material and object are configured, contested and emergent provides a potentially significant point of connection between science and technology studies and theories of material culture. As we have argued throughout the book, one consequence of contemporary divisions of academic labour, and of associated differences of opinion regarding the relevance, possibility and purpose of attending to materials as such, is that co-evolving relationships between substances and objects routinely disappear from view. The result is a necessarily limited understanding of both.

In this chapter we have focused on the definition and valuing of material qualities and performances, and have suggested that these are coloured by actual or future visions of use and application always formulated in relation to existing or imagined alternatives. In short, what materials 'are' and how they are seen depends, in large part, on exactly what they are made into. This relation is complicated by that fact that many items can be made of the same material, that materials are typically combined to produce specific artefacts and that new materials or composites make new products possible.

These observations point to a range of approachable but more specific questions, for example: how do new substances (and products made of them) reconfigure the relational fabric of material interaction? How do coexisting materials embody cross-cutting concepts of style and meaning? Can interventions in design and branding stabilize material reputations and expectations which are in turn relevant in making and shaping future cycles of promise and requirement?

Three of these themes are particularly important for the design of every-day life, the first being the material-object relation and its significance for changing concepts of performance. In science and technology studies it is rare to follow technological innovations beyond critical moments of breakthrough and socio-technical closure or to track their changing fortunes as they bob around in the endlessly choppy waters of consumption and practice. Enquiries of this kind are, however, required if we are to describe and analyse the dynamic taxonomies of quality and meaning that define and are defined by the material relations of the day. There is more to this than following some 'straight' fight between metal and plastic, or between aluminium and steel. The issue is not so much how does one material compare with another but, rather, what concepts of performance do new entrants introduce and with what consequence for the material world as a whole. For example, do new families of complex composites (or nanotechnologies) result in a sort of taxonomic inflation and if so, what does this mean for the relative positioning of all other existing materials?

Second, could we and should we conceptualize materials as 'carriers' or vectors of social and cultural change? We have, for instance, suggested that abstract notions of 'modernity' were materialized in the clean lines and bright colours of Formica laminate tables and melamine tableware. This implies a kind of inseparability or close-coupled feedback between image and material, and between material and object. These forms of cultural-material circuitry are important in setting the scene(s) in which some but not other future promises are made, and in which some but not other future requirements emerge.

Third, the social life of materials (as opposed to things) is evidently a part of material culture. It is so in the traditional sense that materials are imbued with social and symbolic meaning and are subject to as much interpretive

flexibility as is any one object. This final observation brings us back to bronze-age archaeology and to Crace's story about the 'gift of stones'. The concept of an age defined by a dominant material culture makes particular sense if one subscribes to a view in which human progress depends upon scientific and technological mastery of the natural environment. Although Thomsen's three-age system was indeed rooted in the Enlightenment (Trigger 1989), the same is not true for archaeology as a whole and certainly not for archaeology today. In this field, efforts to figure out the relation between coexisting objects of stone and bronze or to follow the 'movement' of the materials as well as the objects of consumption, production and practice are not especially unusual.

Within the social sciences, the task of developing a subtle, socio-technically sensitive cultural biography of a material would require a form of multi-object history, and a method of capturing the changing relation between things made of the same and of different stuff over time. At one level it is hard to see the value of such an exercise, particularly since so many things are made of so many materials. On the other hand, the world of production is still strongly organized by material type, by materially specific expertise and by traditions and systems of industrial classification that date back to medieval guilds. The details are still hazy but an archaeologically inspired social science of materials has the potential to bridge between theories of production and consumption, and to do so in ways that are sensitive to synchronic relations between technologies, things and social structures, and to the development of them all over time (Schneider 1994: 10).

The next chapter takes this discussion of the relation between material and object forward, but from a much more pragmatic point of view. Industrial product designers are quite literally the intermediaries between these two domains: having a hand in the design of what gets made and in what things are made of. It is widely accepted that designers are critical agents in adding value and that it is this which justifies their professional status and their role in the production process. But in the context of the arguments we have developed so far, it is not at all clear what this value is or where it resides – in objects, in the relation between objects, between objects and people, or in practices? It is with this question in mind that we turn to the theories and practices of product design.

CHAPTER 6

Theories and Practices of Product Design

Figure 13 Rapid prototyping concept model. Image courtesy of David Leak

A few years ago it was simpler. Designers just designed things: objects like lamps, chairs, computer mice, cars, buildings, signage, page and screen layouts. Of course we knew that the things we designed affected people's experience. But still, it was enough to design the thing. (Fulton Suri 2003: 39)

Until recently, social theories of material culture, consumption and practice had really very little in common with those that dominate product design, either as an academic discipline or as a profession. As previous chapters have demonstrated, significant and substantial differences in how relations between people and things are defined, framed and understood are born of contrasting philosophical traditions and practical problems. Within the social sciences, it is usual to argue that artefacts exist in a world of changing meaning and symbolic significance, the dynamics of which are of immediate relevance for processes of acquisition, consumption and use. Recognition that the exchange and use values of the 'same' item varies from one setting to another lends weight to the view there is nothing about the physical characteristics of an object, or the intentions and skills of those who designed it, that can guarantee its place in the world of goods. To some extent, this position has been developed in direct opposition to the much more 'essentialist' interpretations that pervade the theory and practice of product design. In writing about theories of design, we focus not on 'Theory' as developed and expressed in the manifestos of design groups and movements, or in attempts to externalize the creative mental processes involved, but on the working understandings that permeate the profession and that are sustained and supported by practical skills and tacit knowledge transmitted through something like a master-apprentice model.

We therefore approach product design as a field in which ideas survive and have effect because they are reproduced by designers and by clients whose commissions and briefs keep them in business. In this chapter we articulate and compare these working understandings. We start with what we term 'product-centred design', the persistent, prevalent and politically important idea that designers can embed economic, ergonomic or semiotic value in objects in the process of turning them into consumer goods. Next

we turn to 'user-centred design', in which value is understood to reside in the relation between people and things, rather than in things alone. Finally, we consider the possibility that value relates to broader concepts of practice and that it is possible to imagine a 'practice-oriented' approach to product design.

Since ideas about the status of objects and hence about the kinds of value that designers add are bound up with the development of the profession as a whole, and its role within complex systems of production and provision (Abbott 1988), we begin by commenting briefly on the history of product design before turning our attention to how contemporary practitioners position and promote their services. Interviews with a selection of practising designers and focus groups with design students demonstrate the existence of a dominant discourse in which generic promises of success through design are matched by contextually specific interpretations of compromise and constraint. Together, these ideas sustain a characteristically absolute view of artefacts and the values they are believed to embody. Although dominant, this is not the only model in circulation. Methods and techniques of user-centred design are often used to develop products that meet what are taken to be pre-existing needs. However, they can also be used to support design processes organized around the rather different view that value lies not in the object itself but in the relation between user and artefact. Some product designers and some commentators on design have started to explore the practical implications of these ideas, and of the related conclusion that users are designers too.

In exploring this latter possibility, we return to questions about the relation between product and practice already introduced in our discussion of kitchens and kitchen appliances, and in previous chapters on DIY and the emergence of digital photography. This time round, we elaborate on the practical and theoretical implications of what we refer to as practice-oriented product design and on the challenges it presents for established ways of conceptualizing design and value. To put these ideas in context we start with a few words on the understandings of value and of the relation between clients, products and consumers around which the design profession has developed and on which it depends.

POSITIONING DESIGN

Historians of product design like Sparke (1983; 1987) and Meikle (1979) underline the close-coupled, recursive relation between the design profession and the structure of capitalist society. In their accounts, the emergence and differentiation of tasks undertaken by industrial product designers mirrors developments in the detail and organization of mass production. For example, Meikle's analysis of 1930s America suggests that this was a period in which manufacturers latched on to design as a way of rejuvenating outmoded products and increasing sales by means of stylistic invention and reform. Functionalist aesthetics, originally promoted by the Bauhaus and initially inspired by the ambition of harnessing the potential of the machine age for the social good, were consequently appropriated in pursuit of profit. From a commercial point of view, design — whether based on cultural creativity or systematic ergonomic method — represented a form of magic, somehow adding something that was not there before.

As is the case in other fields (Abbott 1988), practitioners sought to define the methods of industrial design in making the case for their newly emerging profession – see, for example, publications by Norman Bel Geddes and Walter Dorwin Teague included in Bayley's summary of the defining products of early industrial design (Bayley 1979). Human factors and ergonomic research were not the only point of reference, but both were (and still are) important in bringing process and order to the business of design, and in embedding and reinforcing a distinctively powerful theory of the material world.

Partly because of the classically scientific disciplines of human biology, anatomy and cognitive psychology on which ergonomic traditions draw, human minds and bodies are cast as definable parts of the 'machine' or machinic-system which is the subject of the designer's attention. From a systems-design perspective, the challenge is to understand how functions might be distributed between humans and machines, and how to ensure effective interaction between these various components (Singleton 1974). For example, it is evidently important that the controls of a piece of complex technology are intelligible to those who use them. It is equally obvious that there are different ways of getting this relation

'right': additional user training being one option, designing controls to suit current levels of competence being another (Barbacetto 1987). Similar issues arise in figuring out how sequences of human-machine interaction might be 'programmed' – when should safety catches come into operation and what actions and reactions should technologies permit, prevent and prompt? Enquiries of this kind are informed by an understanding of seemingly universal features like the size(s) of the human hand, the capacity to process visual and auditory information, or the ability to reach and perform actions of push, pull and grip. In practice, artefacts are often configured with some sub-population of users implicitly or explicitly in mind (for example, children, the able bodied, the elderly, or for all of these categories at once – as in 'design for all'), yet the theoretical model remains the same: consumer/user's needs, attributes and goals are taken to be stable and therefore amenable to systematic analysis. Framed like this, good design is that which takes account of human capacities and desires, and therefore results in products that are inherently safe, attractive, easy to use and fit for purpose.

Other styles of design research make use of expertise in semiotics, aesthetics and management, connecting insights from these disciplines in the hope of capturing more elusive qualities of emotion and desire, or of demystifying success and isolating what it takes to produce 'breakthrough' products (Cagan and Vogel 2002; Kelley and Littman 2005). Whatever the method, the dominant discourse is one in which objects have value imparted to them by designers who understand their role in a total functional or symbolic system. In combination, these techniques and ideas lend weight to the conclusion that things which are deliberately designed to 'serve needs and give meaning to our lives' (Heskett 2002: 7) fare better in the market place.

This argument is tremendously important in positioning design, and has been frequently repeated by the UK Design Council, one aim of which is to inspire 'the best use of design by the UK, in the world context, to improve prosperity and well being' (Design Council 2002). A similar logic is replayed at regional level. For example, Advantage West Midlands (in the UK) and the European Regional Development Fund support the Centre for High Value Added Products (based at Birmingham Institute of Art and Design),

one aim of which is to persuade small- and medium-sized enterprises of the power of design as a means of increasing competitiveness.

The thesis that designers can and do add value to products by manipulating 'subconscious emotional cues and tactile and material factors', and by generating an 'emotional resonance and visceral appeal' of a kind that 'sets the exquisite apart from the commonplace' (Seymour Powell nd), has prompted much debate about social and ethical responsibility (Sparke 1983; Papanek 1995; Thackara 2005). Are designers inadvertently but inevitably contributing to patterns of unsustainable consumption? Or are they providing a necessary service in humanizing technology and increasing welfare, for instance by designing for all? As these questions indicate, concerns about sustainability and societal well-being open the way for a more extensive discussion of the normative basis of design and for a more explicit consideration of fundamental questions about whose 'values' are added and marginalized as a result. In the context of the present chapter, the point is not to engage in this debate as such, but to recognize that framing the problem this way locates design as a medium through which social and commercial ambitions are materialized and realized (Sparke 1987: 205).

There are other ways of positioning the role and contribution of product design and, perhaps not surprisingly, designers rarely represent themselves as mere agents of the commercial world. Instead, commentators from within the field emphasize an internally driven trajectory of aesthetic development. Such accounts generally begin by highlighting the importance of modernist principles and with them the desire to minimize the visual and material 'clutter' made possible by the seemingly limitless potential of new materials (like plastic) and the production methods associated with them. In the 1980s, this paradigm is complicated, if not disrupted, by two coincident events: the information technology explosion and the stylistic revolution of post-modernism. Still driven by the ambition of adding value, product designers had to think again about what this meant in the face of these aesthetically unsettling developments. In response, design methodologists embraced the possibilities of computer-aided design (CAD), concentrating more on its implications for the process of designing, than for the nature of the end product. In related areas like architecture, furniture and graphic

design there was a tangible stylistic shift away from modernism and from the ideas that underpinned it. This had its effect on product design as well. During the late 1970s and early 1980s, debates about the changing position of design unfolded in articles and contributions to a variety of journals and magazines including *Blueprint* and *Design Week*, the *Architects Journal*, *Design* magazine and *Architectural Review*, and in television programmes such as Bayley's *Little Boxes* (Bayley 1980). Key figures influential in this decade of change in design theory and practice and in popular journalism include Sparke, Bayley, Woudhuysen, Myerson, Thackara, Dormer and Heskett.

In design as in other practical disciplines, there is no theory without paid work and it is important to notice that these discussions ran in parallel to other equally critical developments in the commercial world in which designers were employed. Also writing of the 1980s, Julier (2000) describes how larger industrial design consultancies in the UK and the USA found themselves working within and contributing to a 'post-fordist' system of production in which distinction and corporate identity were ever more important. In this context, designers were hired to add value by developing corporate images and identifying aesthetic features capable of uniting otherwise disparate products and setting them apart from the competition. This required and implied closer association with related fields like advertising, greater emphasis on packaging and presentation, and attending as much to the symbolic manufacturing of brand identities as to individual products.

In 2004, the UK's Design Council identified yet another 'new role for design as the high-wage economy's response to low-wage economy competition'. The Design Council's review concludes that the spatial dislocation of design, production and consumption is such that future competitive success depends not on manufacturing but on innovation in design. (Design Council 2005b: 8). Thrift (2006: 294) endorses this conclusion, as does Molotch (2003) who also comments on the existence of increasingly influential 'middle men' positioned between manufacturing and consumption, and on the global 'regionalization' of different functions including those of design.

These histories of theoretical positioning, method, aesthetics and employment undoubtedly matter for the 14,841 organizations routinely involved in

industrial and product design in Britain today (Design Council 2005a: 9). But what of the detail? How do changes in production affect the location, status and perceived contribution of design? What do they mean for what product designers actually do and for their understanding of the relation between product and practice? Around 79 per cent of UK design firms employ fewer than five staff and the diversity of the field is such that it would be difficult to track the contemporary salience of different theories and concepts of value across the profession as a whole. It is, however, possible to demonstrate the coexistence of multiple, not always compatible, interpretations of the designer's role and to illustrate some of the complexities involved in negotiating and in thereby enacting and reproducing different understandings of material culture and consumption.

With this ambition in mind we interviewed ten designers working for new and established firms and for companies whose client base ranged from the multi-national to the exclusively local. By way of introduction, Colin, Richard, Peter and Jack run or are employed in fairly well-established middle-sized design companies of between five and fifteen staff. Although constantly and actively looking for new work, these organizations have a solid portfolio of previous projects, a range of experience and certain areas of specialist expertise. By contrast the others – Ian, Eric, Simon, Mike, Dan and Trevor – are part of smaller consultancies employing two to three persons, all of which are just starting out. These still precarious companies have a more reactive style of working driven and defined by the immediate challenge of building a distinctive reputation whilst maintaining a steady stream of contracts. In addition, we organized two focus groups involving final-year and masters students in product design. These students, who had yet to find their way in the 'real world', had many ideas about what they wanted to do, and about the kinds of environments in which they would really like to work. As articulated in the next section, these enquiries suggest that the sociologically puzzling notion that designers inject some sort of absolute value into the *products* on which they work (Grzecznowska 2005), is alive and well in spite, or perhaps because of the discursive effort required to keep this concept in place across a range of unpredictable commercial and cultural contexts.

PRODUCT-CENTRED DESIGN

Despite grand claims about its crucial role in business and in society, design remains something of a mystery both for companies that employ or commission product designers and even for those who do it. What is the special ingredient that designers 'add' to the products with which they interact, what makes for 'good' design, can this be predicted and how should it be valued? Uncertainty on all these fronts is endemic, and is paradoxically fuelled by case studies and stories of success in which design, and design alone, results in a spectacular multiplication of profit. The UK Design Council provides a number of such examples, including one in which spending £80,000 on design led to an £800,000 increase in the sale of kitchen knives (Design Council 2006) and another in which a redesigned toaster exceeded sales forecasts again by a factor of ten (Andrews et al. 2001). Colin, one of the design consultants with whom we spoke, talked of a similar experience:

> for them [the client] it was a fairly low investment in design, 150,000 dollars probably ... it's a very mundane conventional product but we ... whether we were just lucky, or a series of things came together. Within the client company they are saying we've [now] got a category product worth n million, that's the power of design, that's why design can deliver for you. (Colin)

The trouble is that there are other cases in which significant investment in design has no tangible impact at all. The same respondent continues as follows: 'Other times, other projects, we've worked on, we've spent 1.5 million pounds on it and its got to the end and its been ... it just hasn't gone anywhere because consumer products are so fickle' (Colin).

Although design process, research and method are essential in giving order to what designers do and in justifying their claims to generic and therefore generically applicable forms of expertise, following agreed techniques, or moving from sketch design to prototyping, testing and finalizing is evidently no guarantee of success (Bayazit 2004). In discussing why this might be the case, the designers we interviewed subscribed, with equal enthusiasm, to the view that design is something with which an object can be endowed *and* that

value is relative, contextual, situationally specific and therefore inherently unpredictable. Although conceptually incompatible, these positions coexist and interact in ways that are positively useful in making sense of how design 'works' in the real world.

When asked to reflect on the question of why design is sometimes so effective and sometimes not, our interviewees pointed to a range of complicating factors that in their view limited or restricted a product's ability to absorb design such that its value increases. The working understanding was therefore one in which design *does* have effect, through its capacity to embed value within products, but in which that effect is compromised and undermined by various uncontrollable elements of the social, cultural and commercial context.

When talking about the pleasures and frustrations of their role, designers invoked imaginary templates of ideal conditions, dreaming of projects that were ripe for intervention and in which their expertise was used to the full. The fact that most fell short of this ideal is revealing about the tasks with which designers are entrusted, about non-designers' views of what designers do, and about the designers' understanding of non-designers' (including clients') values. It was also important in designers' explanations of how some objects and projects were better able to absorb design than others. For Eric and Simon, one critical difference was between clients who knew they needed design and those who did not. At one extreme, we learned of companies operating in such hugely competitive markets that they risked dropping 'maybe only one or two points' in relation to their rivals if they failed to invest in design. Since this could be enough to take them past 'the tipping point', there was apparently no option but to use design to 'create that little bit of interest on the shelf which is enough for people to pick it [the product] up'. At the other extreme, Dan talked about the ongoing challenge of selling a process defined by a method, the outcome of which is inherently unpredictable. Trevor and Ian also complained that clients 'don't appreciate or understand the process, and don't see the need for it. They don't understand why they have to have it.' Alternatively, and as Mike explained, potential clients approach 'too late', inviting designers to undertake limited and inappropriately superficial tasks – for example, styling the 'skins' of products the functional qualities and engineering of which were already determined. Ongoing debate about whether designers should have a greater

role in 'nailing down ideas', and in thinking through problems, concepts and strategic business directions indicates persistent ambivalence about just what service is provided (for example, how much design is 'enough') and suggests that clients vary enormously in their capacity to consume different kinds of creative input.

More pragmatically, different organizations are indeed more and less experienced in working with product designers. Andrews et al. (2001) write about how companies acquire 'design maturity' and about how knowledge develops from an awareness of the potential commercial benefits of using design, through to an understanding of the more strategic role design can play in helping to attain some kind of company vision. In addition, and as Colin and Richard also argue, opportunities for adding value through design are likely to vary during the course of a product's life cycle. In the following extract, Colin identifies a first phase of innovation-led 'pre-design' during which functionality and novelty are of defining importance:

> When you bring a product to market that is a technological innovation, nobody is going to care two hoots what it looks like, they won't care how it is packaged because the technological benefit of that device is there, it is doing something new, something that no one could do before, but as that product moves through its lifecycle ... somebody is going to make it slightly differently when you've got the second or third [version] you step off the big technological changes and start looking for the small differentiators that are going to make your product incrementally better than somebody else's. (Colin)

Colin's description is similar to that provided by Liddle (1995), whose analysis of the emergence of consumer goods distinguishes between what he labels as 'enthusiast products', 'business products' and 'consumer products'. According to this characteristically linear mode of innovation, an enthusiast product is typically expensive, difficult to obtain, awkward to use and unreliable. Despite all this, it has some novel functionality to which the enthusiast (elsewhere called the 'early adopter') is attracted. At this stage the designer's job is to ensure that the product's appearance represents that novelty. If there seems to be further commercial potential, the next phase of development is driven by the need to establish a mass market (for the 'business' product). At this point, ease of use and availability must be improved, and price reduced. In this context, the designer's job is one of

re-designing for economic manufacture, reliability and intelligibility. At the third stage, when a market has been established, and when the product type is already familiar, the designer's task is to differentiate between rival versions of the 'consumer product', for example by reintroducing some extra functionality or by modifying aesthetic or ergonomic qualities.

In each of these phases, the designer's role is one of modifying objects that exist in order to equip them with specific qualities required for the next stage in their 'career'. The irony here is that product design 'solutions' soon become part of the starting point for further design activity. The 'need' for design is therefore embedded in a never-ending story of product evolution with the result that today's expenditure on design leads, ever more quickly, to the 'need' for further expenditure tomorrow.

Successive rounds of incremental improvement can prompt fundamental re-design but they can also result in a form of closure such that objects become less and less capable of 'absorbing' more. This is most obvious in the case of instantly recognizable products, the form and style of which has acquired iconic status and value in its own right (for example, the form of the Coca-Cola bottle). In these admittedly rare instances, the 'magic' of design is such that it limits the potential for further intervention: having achieved icon status, these artefacts can take no more. The more common situation is one in which symbolic status remains fluid and in which redesign remains possible. Whether this opportunity is exploited or not depends upon a whole host of other considerations, some of which have to do with judgements about the longer-term future of the commodity in question. As the next extract illustrates, designers are sometimes hired to help extend a product's life, in this case through a new approach to packaging.

> What design has done, it has extended the useful life of something that is off patent. It has brought in another set of issues ... two or three years before it came off patent [the company said] we are going to build some other value into this and that is where design has actually done something ... it extended the life of the product because the generics could not afford to spend the five or ten million pounds on the packaging. (Colin)

Two designers went further in their analysis of 'absorptive capacity'. Peter was, for example, of the view that:

There are certain products that have a high functional component. If you look at any product, if you look at an iron and you say the amount of design you can put into an iron would be different to the amount of design you could perhaps put into a bottle of water, you could argue that there is a lot more emotion [in the water bottle] a lot more brand goes into designing an FMCG [fast moving consumer goods]. ... The potential to absorb design is greater, and therefore they have a different need for design. (Peter)

Another commented on the difference between things made during the industrial revolution, this being a period in which 'form and function were quite closely related, like in the design of a steam engine where the cogs make a direct physical connection' – and those manufactured today, this being an age in which new technologies have 'released design from the demands of the material and made it possible to focus on the user more than ever before'. By way of illustration, the capacity to make something like a needle for diabetics into the form and shape of a purse indicates both an increasing opportunity and an increasingly important role for design.

In summary, artefacts are likely to receive designers' attention at different points in their career, and at each of these moments different value(s) are variously amenable to modification. The idea that objects have the potential to 'absorb' and benefit from design is a repeated theme in all of these accounts, in government documents, and in the websites and promotional materials of large and small design consultancies alike. Although not the whole story, these interpretations provide a vocabulary and a set of terms with which to comprehend success and failure. When things do not work out well it is because either the client or the product was, for one reason or another, incapable of soaking up or embodying attributes and qualities of the kind that design has to offer.

USER-CENTRED DESIGN

The argument that business success depends upon really understanding the consumer, and on designing goods and services that really meet consumer needs is consistent with the dominant discourse of product-centred design described above. Even a brief review of what has become known as user-centred design shows how keen designers have been to appropriate and adopt

methods from disciplines as varied as psychology and anthropology, bending them to the task of understanding and delivering what users and consumers want. Innovative techniques of observation, body storming, shadowing, immersion and rapid prototyping (Hannington 2003) are reputedly effective in identifying 'latent' consumer needs, though further work is sometimes required to 'scale up' conclusions drawn from a handful of cases and translate them into all stages of the design process (Aula et al. 2005). In describing the increasing popularity of ethnographic methods, Redström suggests this reflects a basic interest in knowing more about 'people, their capacities, needs and desires' in order to create a 'tight fit' between objects and users' experiences and understandings (Redström 2006: 124).

This ambition is shared by those we interviewed, most of whom were convinced of the value of user, consumer and market research as additions to an existing armoury of more familiar techniques. At the same time they were unsure about exactly what this kind of social science should involve, when and by whom it should be done, and precisely how it might feed in to the 'real' work of design. Colin's response is typical:

> In my time, I've seen a big shift in trying to move closer to what drives consumers … in the old days we'd just be briefed and you'd sketch something and give it back to them, now people say well you've got to go and look at consumers for a week and watch them, and we're going to do landscaping and audits and categorization … it's a very powerful move and it gets you closer to delivering a better product, I'm sure, but I have a bit of a problem with designers doing their own ethnography, it is like designers doing their own market research. (Colin)

Peter also wonders about the relation between design expertise and the knowledge and skills required to deploy 'ethnographic' techniques effectively and interpret the significance and the practical implications of the results.

> These are great tools but if designers embrace them, who has the power to be able to use them? I suppose the ideal team would be the designers, the ethnographers and the social scientists, a multidiscipline team … its just knowing which box you should open and which you should leave alone. (Peter)

However pervasive, the strategy of knowing and then meeting needs is not without its problems. One obvious difficulty is that people inhabit a

constantly changing world of consumer goods. Colin comments on this aspect in particular:

> If you sit with enough consumers and enough bottles of water … eventually you'll understand what the magic key is as to why certain people buy certain things, but the problem is that it is only relevant for that day, that week or that particular set of circumstances, next week those consumers will have seen a whole set of different bottles and will have been exposed to a whole series of different things, so it's a constantly changing cycle. (Colin)

This problem points to a range of other more theoretical challenges. Methods of user-centred design need not unsettle the conceptual basis of the profession or fundamentally challenge its role, but the potential is there, not in the (ethno)methodology as such, but in the underlying theory of situated action on which such approaches depend.

The new 'tools' of user-centred design differ from more traditional forms of ergonomic analysis in that they reflect and require substantial reinterpretation of the relation between people and things, and hence of design itself. Redström gives a hint of what is at stake in his criticism of the whole idea of optimizing and 'designing the user experience', and in his contention that such an ambition paradoxically denies users' routine creativity and precludes interpretations of 'use' as a dynamic, on-going achievement (2006: 137). Berg (1998) makes a very similar case, arguing that the strategy of involving multiple stakeholders with the aim of democratizing design also has the perverse effect of conceptually separating the object and the user, and of obscuring the co-productive and inherently multiple processes through which 'both technologies and human actors acquire their specific characteristics' (Berg 1998: 476).

In some sectors, often those inhabited by global corporations or by companies dealing in information technology, recognition of people's active and creative engagement with the things they use has inspired interest in 'innovation through people-centred design' (Wakeford 2004), and in the notion that professional designers are (or should be) engaged in a continual process of co-creation with a population of amateur 'self-designers' (or users). This proposition, together with the theoretical conclusion that 'the experience of even simple artefacts does not exist in a vacuum but, rather,

in dynamic relationship with other people, places and objects' and that 'the quality of people's experience changes over time as it is influenced by variations in these multiple contextual factors' (Buchenau and Fulton Suri 2000: 424) has potentially profound implications for the design profession and its clients.

Hill elaborates on the implications of the idea that the designer's task is not to produce finalized artefacts but to build 'products which people can adapt and shape to their own purpose' (Hill 2004: 54). As he explains, this might include 'leaving products open for others to complete' or nurturing well-designed amateur solutions (Hill 2004: 56). Overbeeke et al. (2002) extend these suggestions, arguing that 'the designer needs to create a context for experience, rather than just a product'. In this analysis, designers figure as one amongst a range of players engaged in the co-production of value. While there are periods of closure and collective agreement about what things are for and how they should be made and used, such stability is taken to be an outcome of social process, not an expression of human need or of pre-existing consumer demand. This line of argument leads to the challenging conclusion that it is impossible to get the 'human factor' right forever and that it is a fruitless task to even try.

Faced with the cultural relativity of meaning and utility, commentators like Hill (2004) and Heskett have sought to recover a distinctive function for design by suggesting that it 'is a primary element in stimulating the awareness of possibilities' (Heskett 2002: 133), and in generating material resources and contexts from which new (and valued) experiences might emerge. Arriving at the same conclusion, Cagan and Vogel (2002) argue that since

> the interaction of the product with the user and the quality of the resulting activity summarize the overall user experience ... The goal is to understand how to create a product that facilitates a positive user experience (Cagan and Vogel 2002: 180).

Put bluntly, there is a significant difference between the notion that things can embody qualities like those of functionality, ease of use and emotional appeal, and the conclusion that such qualities are emergent outcomes of contextually specific practices. Rather than a design(er) led process in which

products are imbued with values for consumers to discover and respond to, proponents of this more radical form of user-centred design argue that the traffic flows both ways. There are weaker and stronger versions of what this means in practice. One relatively mild reading is that in their adoption and use of existing products, consumers establish value systems and possible directions for future development to which designers respond. Other more extreme interpretations flatly deny the possibility that things absorb design, or that value is in any way a property of the object alone. Strong or weak, theories of user-centred design still focus on individual experiences made possible by isolated products.

In the next section we return to the even more challenging possibility that things and practices interdepend to the extent that objects are 'tied to action'

Figure 14 Modelling objects of the future

(Schatzki 2002: 106) and that designers and designed artefacts contribute to the emergence of collective conventions and shared practices.

PRACTICE-ORIENTED DESIGN

The observation that objects have a 'causal impact on activities and practices' (Schatzki 2002: 197) is consistent with all that we have written about kitchens, DIY and digital photography. In the context of the present discussion, these ideas suggest that designers have an indirect but potentially decisive hand in the constitution of what people do. If material artefacts configure (rather than simply meet) what consumers and users experience as needs and desires, those who give them shape and form are perhaps uniquely implicated in the transformation and persistence of social practice. Kelley and Littman touch upon aspects of this potential in representing what they describe as a verb-based interpretation of design. In their words, 'we think of products in terms of verbs, not nouns: not cell-phones but cell-phoning' (Kelley and Littman 2001: 46).

In writing about the co-constitutive relation between things and practices, and in explaining how human and non-human actors inscribe and modify each other, Preda concludes that objects 'bind human actors and participate in developing specific forms of social order because they allow for common practices to develop, stabilize and structure time' (1999: 353). Extending these observations to the world of design, one conclusion is that in so far as they do add value, designers do so not to individual products but to the complex of material artefacts and practices of which isolated artefacts are a part. Accordingly, values of use and exchange do not reside in individual products or in the meanings attached to them. Instead, and as Graeber also argues, value is best understood as an emergent outcome of the many actions in which goods are embedded and of which they are formed (Graeber 1996; 2001; Tharp 2002).

Practice-oriented product design has yet to be articulated or discussed on any scale (Korkman 2006), but it is nonetheless possible to imagine the further development of an approach that centres not on objects, and not on users and consumers, but on the more encompassing dynamics of practice. Although not yet apparent in academic design publications, aspects of this

way of thinking are hinted at in the website of the design consultancy, IDEO, and in its chief executive's observations about the importance of designing entire ecosystems of interacting artefacts: 'This notion of designing ecosystems of things which interact with each other is a lot of what we're doing today' (Brown 2006). Brown focuses on systems of things but, drawing upon insights and conclusions developed in previous chapters, it makes sense to go one step further and also attend to the relation between such systems and the dynamics of practice. This is particularly important if we accept Warde's (2005) view of consumption as something that routinely takes place not for its own sake but as part of the effective accomplishment of practice, and if we allow that 'needs' emerge (and disappear) as a result of the ongoing reproduction and transformation of practice. Such a strategy changes the relevant unit of analysis and enquiry: rather than persisting with user studies or with market research, designers and their clients might look for ways of understanding and influencing the evolution of practice over space and time. This is not as strange as it might sound, after all, effective product innovations are in any case almost certainly connected to innovations in practice (Shove and Pantzar 2005). If they were really ambitious, companies might go so far as to define markets not as actual or potential customers, and not in terms of where they stand in relation to 'market share', but with reference to the extent to which they are effectively embedded in the dynamics and in the reproduction of the practices of everyday life (Korkman 2006). Taken to heart, a practice orientation would require a more extensive understanding of how materials and practices evolve, circulate and disappear, and a more comprehensive view of the things with and through which we live our lives.

REDESIGNING DESIGN?

As we noticed at the start of this chapter, understandings of design and value are kept alive and kept in circulation by cohorts of clients, designers and others with whom they work. We have so far identified three conceptually distinct approaches, the first and most popular of which supposes that objects meet pre-existing functional or semiotic requirements, and that artefacts embody values that are added through design. By contrast, more

relational theories of user-centred design assume that interpretations of value are mobile, contextual and certainly not inscribed in objects themselves. The third more radical possibility, represented by practice-oriented product design, is that material artefacts themselves configure the needs and practices of those who use them.

Are products and objects taken to be fixed or malleable, and are they seen as active or passive features of everyday life? Although these are critical questions for the theory of product design, they prove to be of little or no relevance for the day-to-day business of running a consultancy, securing contracts or doing what designers are paid to do. Design consultants and commentators move with apparent ease between absolute and relative concepts, at one moment arguing that value arises through interaction between product and user and, at another, that it is an embodied quality (Kelley and Littman 2001; Cagan and Vogel 2002). Tharp also draws attention to this contradiction: 'in some sense value is seen as an absolute with identifiable characteristics, yet at the same time it seems fleeting and mercurial' (Tharp 2002: 8).

Since the underlying logic of their role is always varying, often in ways that are beyond their control, and since contrasting theories of design and value do not necessarily change the design process, or the design brief, persistent theoretical inconsistency is not particularly important for design consultants. After all, they are already undertaking a variety of tasks, responding to clients' requests for services ranging from total project management through to much more limited work in graphic design or CAD modelling. In addition, it is in any case possible to imagine situations in which practice-oriented, user-centred and product-centred framings of design and value coexist.

Somewhat trickier issues arise when the margins of the profession are called into question and when disciplinary territory is eroded or extended beyond product design, and into systems and services or into neighbouring fields like those of management, market research, engineering and production. As discussed above, relational theories of user-centred design have the potential to challenge the foundational and jurisdictional claims of the profession itself. If everyone is a designer, to what special expertise does the profession lay claim? One response, typically adopted by larger design firms, is to argue that concepts like those of 'co-production' serve to expand

rather than restrict the reach and scope of their role. Jane Fulton Suri, also from IDEO, suggests that:

> Designers today have opportunities to design much more than simply static objects. We are designing integrated and dynamic interactions with objects, spaces and services and helping companies with more strategic decisions. Expanded opportunities have spawned developments in traditional design practice (Fulton Suri 2003: 39).

The fashion for so-called ethnographic enquiry within and as part of the design process may indicate the existence, if not the prevalence, of a more fluid and a more culturally sensitive understanding of material culture. Likewise, interest in 'service design' and related swings of methodology may also indicate a more fundamental repositioning of design not only in theory, but also in the political economy of production. On the other hand, the experiences of a few large consultancies are unlikely to be shared by the very many small companies that constitute the bulk of the profession. As our interviews demonstrate and as the design literature confirms, user-centred methods are increasingly widely adopted, but without changing or necessarily challenging designers' roles in the way that Fulton Suri describes.

The ambitions of the final-year design students included in our focus groups illustrate the durability of 'absolute' theories and models of product design. For Carol, the ideal scenario was one in which she would see a design project through from start to finish:

> You know it is right at the point of conception, as you're designing a product you're ensuring all the way through that it doesn't get lost … that by the time it hits the market place the basic idea is still intact (Carol).

Agency of this kind is rare, even for those working on in-house design teams, and it is important to remember that these student ideals are uncomplicated by the experience of hustling for contracts. Even so, their sentiments are worlds apart from the models and visions of commentators who underline consumer creativity (Silverstone and Haddon 1996), who make much of the 'pro-am revolution' (Leadbeater and Miller 2004); or who simply acknowledge users' vital and defining role in innovation (Shove and Pantzar 2005) and in the design of everyday life.

Like other professions, designers are bound to a set of tasks by what
Abbott (1988) describes as ties of jurisdiction. These tasks and ties are
established and reproduced through the process of professional work
(Abbott 1988: 33). In other words, what designers *do*, and how they go
about their business is intimately related to the sort of expertise they
lay claim to and the kinds of values they purport to add. The idea that
products are becoming more similar in 'technology, functionality, price and
quality' may prompt some clients to turn to design for a different sort
of expertise (Fulton Suri 2003), including expertise in understanding the
dynamic relation between things and those who use them, or in crafting
interventions that foster innovation in practice. But not all clients are in
the same boat. The result is a profession in which competing paradigms
coexist, and in which a handful of consultancies and clients are currently
exploiting relational interpretations of design and practice as a means of
distinguishing themselves from others still committed to a more essentialist
view of what the business is all about.

Whatever the future holds for designers or for those who employ them,
one general conclusion remains: opportunities for product design and inter-
pretations of what that involves have been and continue to be structured
by the social and institutional organization of manufacture, by the relative
significance of mass and batch production, by the reach and range of
different markets and by changing ideas about the relation between people
and things. Product designers rarely determine what gets made, but their
working methods embody and reproduce ideas and concepts that matter
for the detail of material culture and for the practices of which it is a part.
As such our study of product design provides a partial view into a wider
world of manufacturing and production, and into working – rather than
academic – understandings of the relation between objects and their users
and consumers.

These closing observations remind us of the point that specific items
like plastic washing-up bowls, Speedfit plumbing fittings, digital cameras
and kitchen fittings arise from and contribute to a wider political economy
of material culture. In addition, they provide just a glimpse of the ways in
which ideas about that culture feed back into the hardware and hence into
the design of everyday life.

CHAPTER 7

Products, Processes and Practices

Figure 15 Social fabric

In this book we have tracked down some of the ways in which material objects are of consequence for the development, persistence and disappearance of patterns of everyday life. There are already well-trodden paths through this academic ground – much has been written about relations between technologies, people and material artefacts. Yet in the introduction we identified a range of conceptual gaps and questions left stranded by the main highways of theoretical enquiry as these have developed within sociology, in studies of technology, material culture and consumption, and in design. We sought to move into these shadowy areas, recovering bits of missing debate and bringing them out into the open. To begin with we concentrated on a catalogue of orphaned but seemingly unrelated questions: how to go beyond the study of things as carriers of semiotic meaning? How to think about the agency not only of individual artefacts but of interrelated complexes of stuff? How might we conceptualize the materials of material culture and how do objects and practices co-evolve? In addressing these topics we have travelled between domestic kitchens and design studios, enquired into DIY stores and darkrooms, and delved into the history of plastic houseware. Along the way we have exploited different disciplinary perspectives raiding ideas and concepts from here and there in an attempt to capture and represent aspects of the relation between materials, objects and the doing of daily life. In this last chapter we take stock of where this process has led. What are the practical and theoretical implications of the arguments and propositions we have developed from this eclectic combination of conceptual and empirical materials?

We begin by reviewing the route we have taken, pausing along the way to draw out key findings from our empirical research and relate these to the missing debates identified above. In the process we assemble the pieces of what has in fact been a cumulative narrative involving the progressive development of a series of interlinked positions and propositions. The result is not a comprehensive model in which different strands of enquiry knit together but a rough map describing promising-looking pathways and defining directions for future journeys that cut into fresh intellectual territory. This mapping exercise has practical implications for product design and, in the longer term, for the resource intensity and sustainability of everyday life itself: as such it is of more than academic interest.

CONNECTING CONCLUSIONS

Consistent with our interest in ordinary consumption, we started in the kitchen. There are many possible explanations for why people renew kitchens and acquire new appliances: some focus on status and the projection of self-image, others on the pursuit of novelty for its own sake and/or on the pressures exerted by powerful commercial interests. In Chapter 2 we explored the further possibility that kitchen units, freezers and kitchen tables are acquired and desired not for their own sake but for the practical arrangements they make possible. This led us to conclude that kitchen renewal is not merely an outcome of contemporary consumer culture, or an expression of the challenges of constructing a post-modern identity. It is also powered by the practical exigencies of accomplishing specific practices in a given physical and material environment. This insight prompted us to think about the dynamic relation between having (things) and doing (i.e. accomplishing valued social practices). Our respondents told us about three alternative formulations. In some situations the materiality of the kitchen is pretty well aligned with what goes on, and what goes on is in turn pretty well aligned with how people think family life should be. This state of provisional equilibrium arises in different ways, for example, through constant co-adaptation of stuff and practice, or because both are in any case relatively stable. In other situations the physical form of the kitchen or the equipment it contains prevents people from accomplishing what they take to be normal or necessary practices in the way they would like. Finally, we learned of efforts to acquire new goods or reconfigure space so as to induce desired outcomes like those of family togetherness or domestic efficiency, and we heard about cases in which kitchens and their contents 'demanded' practices that were in the event unrealized – as demonstrated by abandoned bread makers and underused ovens. In combination, these accounts indicated that consumption is organized in terms of past, present and future practice and that things are acquired, discarded and re-designed with reference to culturally and temporally specific expectations of doing *and* of having – not of having alone. From this discussion we highlight three critical observations:

1. Patterns of consumption relate to future-oriented visions, not only of having but also of doing.
2. Doing matters for having and having matters for doing.
3. It takes energy and effort to keep having and doing in balance, and to maintain a provisional equilibrium in which conventions and visions of domestic life are preserved and reproduced.

The theoretical implications of the rather prosaic conclusion that people buy things because they 'need' them to accomplish valued social practices require further working through. In Chapter 2 we made a start by detailing relations between what is owned, what is done today and what could or should be done in the future. Rather than acquiring or aspiring to possess products for their own sake, people wanted things in order to furnish and equip themselves with what they took to be the defining ingredients of an effective configuration.

The practicalities of doing even simple tasks, like cooking a meal, generally involve the active orchestration of an array of material artefacts. In making dinner, multiple things have to be brought together in a spatially and temporally structured arrangement. This is routinely the case for accomplishing just about anything at all, a point that leads us to suggest, with a debt to Donne's more famous phrase, that 'no object is an island' (Donne 1624). The relation between things was a defining theme of Chapter 3, and of our discussion of the projects and practicalities of *doing* it yourself. In considering the framing and shaping of projects, we noticed that interpretations of utility and need were closely connected. There are two aspects to this. First, hammers and nails, nuts and washers, and many other items, only have effect in relation to each other – again a simple observation but again one that is routinely missed by those who study artefacts in isolation. Second and in many ways more interesting, our study of DIY indicated that effective configurations are necessarily composed of meanings and competences, not of material objects alone.

The historical development of DIY is marked by the changing properties of products and their role in defining and in moving boundaries between what householders are and are not prepared to do for themselves. Willingness to do any DIY at all varies widely, as does the range of tasks that individuals

actually tackle, yet there are discernable trends resulting in what at first sight looks like the deskilling of previously challenging projects. The concept of the person-tool hybrid provides a more subtle way of thinking about these processes, and about the possibility that competence is itself distributed across complexes of tools, materials, intermediaries and human beings. Put more abstractly, it seems that competence, at least in DIY, can be usefully understood as a relational attribute that emerges from and through performative relations between human and non-human actors.

This makes sense at different scales. New technologies, from power tools to varnishes, have extended the range of what individuals do themselves. Critically, the dynamic redistribution of competence between person and tools/materials also plays out in terms of the relations between people and people, for instance in determining whether tasks are located in the formal or the informal economy. This is a point of relevance to more than DIY: objects matter for distributions of competence that are in turn relevant for systems of provision and hence for the relation between markets in products and services. This is not all that matters, but in recognizing that there is some such connection, we begin to see possible synergies between a Latourian view (not only of distributed agency and cognition but of competence too) and Durkheim's analysis of the division of labour (not only between humans but also between humans and things, and even between things and things) in society. Linking these observations together, we arrive at our next three summary points.

1. The reproduction of everyday life involves actively and effectively configuring and integrating complex assemblies of material objects – it is not a matter of appropriating or of being 'scripted' by isolated artefacts.
2. Effective configurations are composed of materials, but also of meanings and forms of competence.
3. Competences are frequently distributed between persons and things. These distributions matter for divisions of labour and for the formulation of projects and practices.

As the previous sentence indicates, our analysis of DIY demonstrated the relevance of mid-range ordering concepts like that of the 'project'.

In everyday life, projects, which take many forms, are significant devices deployed in bounding and in making sense of the temporal flow, and in actively orchestrating and interweaving complexes of practices. Many projects – whether renewing a kitchen or putting up a shelf – are undoubtedly generated by 'external' events and pressures like those associated with the life course, or with a gradual accumulation of possessions. Many others seem to have what can best be described as an internal dynamic and a life of their own.

In the context of DIY, projects typically involve an iterative process of interaction between one or more persons and tools, intermediaries, materials and the fabric of the home. Such interventions are inherently unpredictable, not only in terms of the extent to which the desired effect is achieved but more interestingly and more broadly in the sense that doing is multiply transformative, not only of the property but also of the DIY practitioner and of the kit of tools and materials with which they work. The implications of accumulating experience are diverse: in some cases skills increase, in others frustrations build up to the extent that practitioners refuse to ever try to do it themselves again. In any event, embarking on one project changes the conditions of possibility for future projects and reconfigures the 'landscape' in which they are formed. Whether the result is one of disappointment and defection or renewed enthusiasm, there is a clear and ongoing connection between competence and project that works in two directions. Different projects are contemplated (or not) depending on past experience. Equally, experience grows (for good or ill) in the process of tackling projects. DIY may be an especially unusual case, and further research would be required to show if it is, but we have the suspicion that similar processes drive and animate other areas of everyday life and that this cyclical relation between materials and competence, and between competence and project – and hence consumption – is important in other fields as well. We therefore draw attention to the possibility that *projects, formed of interrelated sets of practices, have emergent consequences for the accumulation of competence and for the 'careers' of the practitioners involved.*

This provisional conclusion was borne out in Chapter 4's discussion of the digitization of amateur photography. In that chapter we investigated the practical significance of the arrival of new materials and technologies into

an already well- established field. This technique allowed us to concentrate in particular on the relation between products and the dynamics of practice. There were several levels to our enquiry. We showed how individuals with very different previous photographic experience 'went' digital and we invest-igated the detail of 'doing' digital photography and of taking, manipulating, viewing and storing digital images. These experiences showed that existing familiarity with home computing and/or with film photography spilt over and constituted a necessarily diverse and uneven territory into which specific digital devices were appropriated. Appropriation was not a process that ended in closure, nor was it one in which new equipment was domesticated and merged into an unwavering regime of existing practice. Instead, we observed and followed the development of emerging forms of competence, enthusiasm and capabilities, and of disillusion and disappointment as individual digital photographic 'careers' unfolded (Becker 1963).

These individual responses together define a more generic pattern. It is clear that digital has disrupted the film-based material ecology of amateur photography: many previously valued bits of equipment have been scrapped as a result. But it was also clear that this is not an inevitable outcome. Instead, trajectories of innovation and fossilization (in which once important links between materials and competences are broken) intersect (Shove and Pantzar 2006). The more people that do digital photography, the more normal it becomes. Equally, as film becomes an interest of a few, rather than a mainstream habit, so relevant skills begin to fade and so the chances of future recruitment diminish. In Chapter 4, we sought to show what individual performances meant, in combination, for the also emergent trajectory of amateur photographic practice-as-entity. Since practices exist only as long as there are people who perform them, we paid particular attention to the routes by which 'carriers' were captured either by film or by digital, and to the ways in which photography took hold in their lives. Framed like this, we were able to consider the relation between digital technologies and the changing direction of the practices of which they become a part.

This is not a process of which anyone is clearly in control. Major companies have much to gain, and also much to lose, from the widespread embedding of digital photography. Relations between the different organ-izations involved in making cameras, computers, mobile phones, printers

and printer paper, CD writers and in-store print machines are undoubt-edly relevant. At the same time, it would be difficult to claim that new phenomena of digital imaging such as online photo and video communities are the outcome of some pre-planned commercial campaign. In taking and managing digital pictures, amateur photographers are engaged in creatively integrating complexes of existing and new technologies through countless performances of what is a dynamic but at the same time continuous prac-tice. While some conventions, like those of composition, have proved to be relatively stable, others relating to the ways in which photographs circ-ulate through email or via phones and web galleries are clearly on the move. Amateur photography has never been a singular pursuit yet the possibilities engendered by contemporary conjunctions of material, competence and rationale are so extensive that it is impossible to anticipate what new forms and patterns might emerge next. These observations lead us to the view that:

1. Practitioners' careers, formed of many instances of performance, com-bine to define the career of a practice-as-entity.
2. The trajectories of practices-as-entities are inherently unstable, depend-ing as they do on the recurrent integration of materials, images and forms of competence by more or less 'faithful' cohorts of practitioner-carriers.
3. Product innovations consequently relate to innovations in practice, but not in ways that are easy to control or anticipate.

With these arguments more or less in place, we turned back to other fundamental matters of materiality. What are things made of, how do the substances and images of (raw) material culture relate to the production of individual consumer goods, and how do product designers fit into this equation and into related debates about the connection between product, process and practice? In addressing the first of these questions we picked on the history of plastic, using this as a means of connecting generic accounts of technological innovation with more culturally specific analyses of individual artefacts. This led us to identify interdependent promise-requirement cycles looping between the conventionally separate worlds of production and consumption. In writing about the forms of cultural-material circuitry

through which plastic makes plastic products and plastic products make plastic, we tried to bridge between theories of production and consumption and to do so in ways that were sensitive to synchronic relations between technologies, things, practices and social structures, and to the development of all over time.

We then investigated theories and practices of product design, doing so on the grounds that this would provide some insight into commercial representations of the relation between things and people, and into the kinds of assumptions and understandings that are built into, and that therefore emerge from, the practicalities of production and design. This exercise led us to identify three analytically distinct approaches: a dominant theory of product-centred design in which value resides in the object itself; an interpretation of user-centred design in which value is defined by the relation between consumers and the things they use; and practice-oriented design which recognizes the active, cumulative and sometimes generative part things play in the reproduction and transformation of practice. This latter position leads to the conclusion that value is determined in relation to the always changing practices in which products are integrated. Given that working theories are those that circulate and survive in the 'real' world, it is significant that currently dominant interpretations revolve around a view in which objects are thought to meet pre-existing needs and in which their role in practice and hence in making demand is routinely understated.

To the points already made, we add three further observations developed in Chapters 5 and 6:

1. Symbolic relations between materials and objects are co-determining and cumulatively important for what gets made and for what things are made from.
2. The details of material culture reflect producers' and designers' (working) theories of the relation between things and people.
3. In supposing that things meet needs, dominant theories of design overlook the possibility that needs are the outcomes of practice and that materials are themselves implicated in the reproduction and transformation of the design of everyday life.

IMPLICATIONS AND DIRECTIONS

In the course of developing these ideas we have made new connections between established areas of debate in the social sciences. In addition, we have arrived at a set of connected propositions and suggestions that are of practical relevance for designers and their clients and, more generally, for the future fabric and resource intensity of everyday life. In this final section we elaborate on these different contributions, considering the challenges and questions they engender.

We start with four points of disciplinary intersection all of which deserve further attention. First, the idea that artefacts have the capacity to construct social order (Latour 2000) requires some qualification from the point of view of a materialized version of practice theory. As elements in the dynamics of practice, technologies are implicated in the construction and reconstruction of social relations. However, an object's role in stabilizing social relations depends upon its continuing integration into successive performances through which those provisionally stable relations are faithfully reproduced. Objects can be more or less powerful in perpetuating these performances, but they can never preserve social relations by themselves. The fundamental point here is that it is the integration of the elements of practice which (for a time) sustains a given order. By the same token, to the extent that new technologies are integrated into what are of necessity somewhat new performances, so they are of consequence for the constitution and emergence of new practices.

Second, and again resulting from a novel conjunction of theories of practice, culture and technology, Schatzki's (1996) distinction between practice-as-performance and practice-as-entity has far-reaching implications for discussions both of domestication (Silverstone and Hirsch 1992) and of scripting (Akrich 1992). The point here is that as things are integrated into practices-as-performances – and regardless of whether the emphasis is on how they configure and script or on how they are appropriated and domesticated – so they are of consequence for the emergence of practices-as-entities. This observation underlines the importance of attending to collections of things and to relations between things that are jointly implicated in the conduct of practice. But there is more to it than that.

Trajectories of material-material and human-material complexes evidently co-evolve. Less evident is the observation that these collective trajectories are formulated through enactments of practice and that each such performance changes the conditions of future rounds of integration. These comments suggest, first, that processes of domestication and scripting never end and, second, that they are implicated in making and shaping the moral economy and the architecture of practice itself.

Third, we have opened up a range of questions to do with the materials of material culture. We have also concluded that there are fruitful connections to be made between technology studies, anthropology and archaeology, and between generic analyses of innovation and the more overtly cultural study of artefacts. In writing about plastic we explored these possibilities by looking at the intersecting 'narratives' that organize and orchestrate relations between substances and things (Rip et al. 2006). We focused on relatively easy cases, studying cups, plates and washing-up bowls rather than cars, aeroplanes or other much more complex composite entities. Yet the questions we asked of plastic and the material substance-artefact tensions we identified are worth exploring in other settings. For example, it remains to be seen how the promise-requirement cycles of innovation and investment intersect with those of culture and consumption in areas like the currently fluid territory of nanotechnology.

Fourth, there are various ways in which the ideas developed in this book promise to be of value in academic discussions of design. At the most general level, theories of practice are capable of bringing traditionally separate lines of enquiry, including those represented by the study of man-machine systems (Singleton 1974), by 'product semantics'[1] and by 'emotional design' (Norman 2004), together in a single conceptual framework. There are other more detailed points of connection. For example, our account of distributed competence provides designers with a new way of conceptualizing what they refer to as 'feature creep', this being the tendency for devices to absorb functions previously fulfilled by those who use them. The anti-shake feature of modern cameras is a good example of the ways in which challenges like those of not wobbling are literally taken out of the users' hands and embedded in the object itself.[2] Other such cases include selective focus based on face-recognition software, anti-lock

braking systems in cars and automatic piloting of aeroplanes, all of which involve reconfiguring and redistributing competence between human and non-human actors.

Likewise, our analysis of the complex relation between innovation and convention is useful in understanding the details of product design and the extent to which these tensions are materialized. In the field of photography, the many radical camera forms that were generated in the decade following Sony's introduction of the first still video camera in 1981[3] largely failed to dislodge accepted norms of camera morphology. The effects of contemporary 'feature creep' combine with these historical conventions in creating expectations of what constitutes a digital camera today. These expectations are so powerful that despite the potential for more substantial innovation, rival products are differentiated by only minor variations of detail. By implication, the effective embedding of 'the camera' in practice structures the nature and the possibility of intervention by design.

Finally, our review of the theoretical basis of user-centred approaches resonates with moves toward what we might think of as 'open-scripted' if not 'open- source' product design. Dunne (2006) has suggested that users approach the functionality of digital cameras in an inquiring and exploratory way, developing personal strategies for coping with the many capabilities on offer after the point of purchase. This is, says Dunne, in contrast to the conventional film photographer whose choice of camera was determined by prior competence and knowledge of the field. Could, and perhaps should, objects be designed to allow customization in use, for example by increasing (not reducing) wide-ranging functionalities and thereby enabling and encouraging adaptation, appropriation and assembly? And if so, what new combinations of social science and design might be required in support?

These questions and issues derive from and at the same time invite new forms of interdisciplinary exchange. As such they define an agenda for further academic debate. Having summarized the key elements of our argument, and having now pointed to promising areas of future enquiry we could legitimately bring this book to a close. But before we do so, it is important to notice that the themes we have developed are also relevant for material and political intervention in the design of everyday life.

Designers generally are employed by commercial enterprises that are attracted by the idea of adding perceived value in order to drive up prices and profit margins. As we argued in Chapter 6, this approach is significantly limiting both of what gets made and of how the relation between consumption and production is conceptualized. Companies and the designers they hire tacitly recognize that the effective embedding of one new product frequently generates new niches ripe for further development, but in failing to appreciate the processes involved in integrating things in practice they fail to make the connection between product innovation and innovation in practice. In making this point, we identify the possibility of an approach in which business interests are explicitly or strategically related to the evolution of practice.[4]

The concept of designing services and of framing design in terms of verbs rather than nouns (Kelley and Littman 2001) both build on the idea that the orchestration of practice provides a new focus for commercial activity. Taken seriously, these developments imply potentially dramatic changes in the positioning and role of product design, and of other more powerful professions like advertising and market research, the existence of which depends upon the durability and persistence of conservatively product-centric theories of markets and individualistic concepts of consumer choice. At the same time, the globalization of manufacturing capabilities is evidently complicating and challenging established ways of doing and of thinking about business. Companies can develop product ranges that are not limited by the production facilities they own; product ranges can begin to reflect the assemblies that practitioner-consumers have put together for themselves and in some sectors the boundary between the realm of production and of consumption is increasingly indistinct (Franke and Shah 2003). In addition, and in ways we have yet to acknowledge, the global circulation of ideas, materials and artefacts is surely significant for the localized emergence, persistence and disappearance of practice (Shove and Pantzar 2005).

Although we have been writing about 'little' things, like photo albums and plumbing fittings, we have also been telling a big story that has wide-ranging implications for resource consumption and for environmental policy makers, many of whom are increasingly aware of the systemic nature of the problems they face, and of the extent to which social, technical and

natural processes interact. Recognition that most consumption, including environmentally significant consumption, takes place not for its own sake but as part of the effective accomplishment of social practice generates further crucial questions about how valued routines and social arrangements arise, persist and disappear (Jalas 2006). How are more and less sustainable ways of life reproduced in and through myriad localized moments of enactment; how, when and where do complexes of practice emerge and disappear and what loops of positive and negative feedback are involved? We do not have the answer but we are fairly sure that relevant clues and intellectual resources are to be found in materialized theories of practice of the kind we have developed in this book.

Notes

CHAPTER 2

1. In each household we identified and interviewed one 'primary' respondent, including other members of the household if they wanted to join in. Fifteen of the forty households were couples living with dependent children, seventeen were couples without dependent children at home, and eight were single-person households. Five interviews were conducted with men, nineteen with women and sixteen with couples. Women are over-represented in the sample, although when including couples, twenty-one men were interviewed. All respondents were white and ages ranged from twenty-four to eighty years; no age group was disproportionately represented in the sample or in each household type.

CHAPTER 3

1. For example, about 60 per cent on cleaning and about 15 per cent on gardening (ONS 2001b)
2. The *Compact Oxford English Dictionary* and the *Cambridge Advanced Learners' Dictionary* identify 'DIY' as British/UK.
3. B&Q's total reported sales fell 3.7 per cent to £3.9 billion. Retail profit of £208.5 million, down 52.0 per cent in fifty-two weeks ending 28 January 2006 (Kingfisher 2006)
4. Of course, the diversity of hammers – pin, ball pein, claw, club, lump, sledge, brick, scotch hammer, mallet, mell, etc. – shows that hammers

can be very highly specialized instruments – but the ubiquitous claw hammer is nevertheless outstandingly versatile.

CHAPTER 4

1. The 35mm format (1914) established a new level of standardization. The release of Kodachrome in 1935 marked the arrival of colour photography on the mass market. Subsequent inventions included the Polaroid instant camera (1948), instant colour film (1963) one-step instant photography (1973) and the first point-and-shoot camera package (1978).
2. These were *Cyanistes caeruleus*, commonly known as 'blue tits' in the UK.

CHAPTER 5

1. Up to this point in the book, we have used the term 'material' rather loosely, taking it to refer to collections of objects as well as to the substances of which these objects are made. In this chapter, we use 'material' to describe material substances, like wood, aluminium and plastic, rather than discrete objects.
2. First encounters were more likely to be with decorative objects than with weapons of bronze.
3. A notable exception is Schneider's (1994) historical anthropological analysis of polyester, which explores the ways in which polyester was (re)configured within consumer-producer-fibre relations.
4. These images were apparently effective for one source suggests that 'Plastic dinnerware was such a popular alternative to china that by the late 1950s, about 50 per cent of all dinnerware sold was moulded using melamine' (http://www.seacoastonline.com/2003news/09242003/it/51835.htm). This was so despite the fact that at the time, melamine was 'much more expensive than ceramics' (Katz 1978: 88).
5. Prices translated using http://eh.net/hmit/ukcompare/.

6. Handley (1999: 29) includes a reproduction of a map of 'Synthetica' produced by Ortho Plastic Novelties and published in *Fortune* magazine in 1940. It shows the new synthetic countries and illustrates features like 'Rayon Island', the acetic acid lake and the great acetylene river.

CHAPTER 7

1. Defined by Krippendorf and Butler as 'the study of the symbolic qualities of man-made forms in the context of their use' (1984: 4).
2. The Pentax Optio A20, launched in 2006, has no less than three types of anti-shake function (http://www.dpreview.com/news/0608/06082103pentaxa20.asp).
3. This was a device that took still images and stored them as single frames of video (http://www.digicamhistory.com/1980_1983 .html).
4. For a concise summary of such an approach, see the POPD Manifesto, available via www.lancs.ac.uk/fass/projects/dnc.

Bibliography

Abbott, A. (1988), *The System of Professions*, Chicago: University of Chicago Press.

Akhurst, S. (2004), 'The Rise and Fall of Melamine Tableware', *The Plastiquarian*, 32: 8–13.

Akrich, M. (1992), 'The De-Scription of Technical Objects', in W. Bijker and J. Law (eds), *Shaping Technology/Building Society: Studies in Sociotechnical Change*, Cambridge, MA: MIT Press: 205–24.

Andrews, S., Ingram, J. and Muston, D. (2001), 'Product values and brand values in SMEs – a case study', *4th European Academy of Design Conference, 'Desire, Designing, Design'*, Aveiro, Portugal.

Anon (1862), 'Parkesine', explanatory leaflet, from www.plastiquarian. com/styr3n3/parkesine/parkesine2.htm

Appadurai, A. (1986a), 'Introduction: commodities and the politics of value', in A. Appadurai (ed.), *The Social Life of Things: Commodities in Cultural Perspective*, Cambridge: Cambridge University Press: 3–63.

Appadurai, A. (ed.) (1986b), *The Social Life of Things*, Cambridge: Cambridge University Press.

Attfield, J. (2000), *Wild Things: The Material Culture of Everyday Life*, Oxford: Berg.

Aula, P., Falin, P., Vehmas, K., Uotila, M. and Rytilahti, P. (2005), 'End-User Knowledge as a Tool for Strategic Design', *Joining Forces. International Conference of Design Research*. University of Art and Design, Helsinki: 24 – 25 September.

Backman, J. (1965), *Studies in Chemical Economics I: Competition in the Chemical Industry*, Washington DC.

Baker, K. and Kaul, B. (2002), 'Using multiperiod variables in the analysis of home improvement decisions by homeowners', *Real Estate Economics*, 30 (4): 551–66.

Barbacetto, G. (1987), *Interface. How Man and Machine Communicate*, Milan: Olivetti Design Research by King and Miranda Arcadia Edizioni.

Bayazit, N. (2004), 'Investigating design: A review of forty years of design research', *Design Issues*, 20 (1): 16–29.

Bayley, S. (1979), *In Good Shape: Style in Industrial Products 1900–60*, London: Design Council.

Bayley, S. (1980), *Little Boxes*, Horizon TV Series, British Broadcasting Corporation.

Becker, H. (1963) *Outsiders: Studies in the Sociology of Deviance*, London: Free Press of Glencoe.

Berg, M. (1998), 'The politics of technology: on bringing social theory into technological design', *Science, Technology and Human Values*, 23: 456–90.

Bijker, W. (1992), 'The social construction of flourescent lighting or how an artifact was invented in its diffusion stage', in W. Bijker and J. Law (eds), *Shaping Technology Building Society*, Cambridge, MA: MIT Press: 75–102.

Bijker, W. (1995), 'Sociohistorical technology studies', in S. Jasanoff (ed.), *Handbook of Science and Technology Studies*, Cambridge, MA: MIT Press: 229–56.

Bijker, W. (1997), *Of Bicycles, Bakelites and Bulbs: Towards a Theory of Sociotechnical Change*, Cambridge, MA: MIT Press.

Blaszczyk, R. (2000), *Imagining Consumers: Design and Innovation from Wedgewood to Corning*, Baltimore, MD: Johns Hopkins University Press.

Bogdon, A.S. (1996), 'Homeowner Renovation and Repair: The Decision to Hire Someone Else to Do the Project', *Journal of Housing Economics*, 5 (4): 323–50.

Bourdieu, P. (1984), *Distinction: A Social Critique of the Judgement of Taste*, London: Routledge and Kegan Paul.

Bourdieu, P. (1990), *Photography: A Middle Brow Art*, Cambridge: Polity Press.

Bowker, G. and Starr, S. L. (1999), *Sorting Things Out: Classification and its consequences*, Cambridge, MA: MIT Press.

Brown, T. (2006), *Gallery Walkthrough with IDEO CEO Tim Brown*, from www.podtech.net/home/?p=834

Buchenau, M. and Fulton Suri, J. (2000), 'Experience Prototyping', *Proceedings of the Conference on Designing Interactive Systems: Processes, Practices, Methods, and Techniques*, New York: ACM Press.

Buchli, V. (ed.) (2002), *The Material Culture Reader*, Oxford: Berg.

Cagan, J. and Vogel, C. (2002), *Creating Breakthrough Products: Innovation from Product Planning to Program Approval*, London: Financial Times Prentice Hall.

Callon, M. and Law, J. (1997), 'Agency and the hybrid Collectif', in B. Smith and A. Plotnitsky (eds), *Mathematics, Science and Postclassical Theory*, Durham and London: Duke University Press: 95–117.

Campbell, C. (1992), 'The desire for the new: its nature and social location as presented in theories of fashion and modern consumption', in R. Silverstone and E. Hirsch (eds), *Consuming Technologies*, London: Routledge: 48–66.

Campbell, C. (2005), 'The craft consumer: Culture, craft and consumption in a postmodern society', *Journal of Consumer Culture*, 5 (1): 23–42.

Castells, M. (1977 [1972]), *The Urban Question: A Marxist Approach*, London: Edward Arnold.

Castells, M. (1996), *The Rise of the Network Society*, Oxford: Blackwell.

Chalfen, R. (1987), *Snapshot Versions of Life*, Bowling Green: The Popular Press, Bowling Green State University.

Childe, V. (1939), *The Dawn of European Civilization*, London: Kegan Paul.

Cieraad, I. (ed.) (1999), *At Home: An Anthropology of Domestic Space*, Syracuse: Syracuse University Press.

Cieraad, I. (2002), '"Out of my kitchen!" Architecture, gender and domestic efficiency', *Journal of Architecture*, 7: 263–79.

Clarke, A. (2001), 'The Aesthetics of Social Aspiration', in D. Miller (ed.), *Home Possessions*, Oxford: Berg: 23–46.

Clarke, A.J. (1999), *Tupperware: The Promise of Plastic in 1950s America*, Washington DC and London: Smithsonian Institution Press.

Conran, T. (1977), *The Kitchen Book*, London: Mitchell Beazley.

Corn, J. and Horrigan, B. (1996), *Yesterday's Tomorrows: Past Visions of the American Future*, Washington DC: Summit Books.

Cowan, R.S. (1983), *More Work for Mother: The Ironies of Household Technology from the Open Hearth to the Microwave*, New York: Basic Books.

Cowan, R.S. (1985), 'How the refrigerator got its hum', in D. MacKenzie and J. Wajcman (eds), *The Social Shaping of Technology*, Milton Keynes: Open University Press: 202–18.

Crace, J. (1988), *The Gift of Stones*, London: Picador.

Csikszentmihalyi, M. and Rochberg-Halton, E. (1981), *The Meaning of Things: Domestic Symbols and the Self*, Cambridge: Cambridge University Press.

Dant, T. (2005), *Materiality and Society*, Maidenhead: Open University Press.

De Certeau, M. (1998), *The Practice of Everyday Life*, vol. 2, Minneapolis: University of Minnesota Press.

Design (1966), 'Editorial, Products, Interiors, Events, Ideas', *Design*, 211: 58–63.

Design (1968), 'Editorial, Duke of Edinburgh's Prize for Elegant Design', *Design*, 233: 26–8.

Design Council (2002), *Our History*, from www.designcouncil.org.uk/en/Design-Council/1/Our-history/

Design Council (2005a), 'The business of design', from www.designcouncil.org.uk

Design Council (2005b), 'Futureproofed, 2004–05 Review', from www.designcouncil.org.uk/en/Design-Council/3/Publications/Futureproofed/

Design Council (2006), *Harrison Fisher. Facing the Competition*, last update 12 December 2006 Retrieved 31.12.06, from www.designcouncil.org.uk/en/Case-Studies/Case-Studies-and-Articles/Harrison-Fisher/

Donne, J. (1624), 'Meditation XVII', *Devotions upon Emergent Occasions*, available from www.online-literature.com/donne/409.

Douglas, M. and Isherwood, B. (1996), *The World of Goods: Towards an Anthropology of Consumption*, London: Routledge.

Dunne, A. (2006), *Hertzian Tales: Electronic Products, Aesthetic Experience, and Critical Design* , Cambridge, MA: MIT Press.

Edwards, E. and Hart, J. (eds) (2004), *Photographs, Objects, Histories: On the Materiality of Images*, London: Routledge.

Featherstone, M. (1990), 'Perspectives on Consumer Culture ', *Sociology*, 24 (1): 5–22.

Fisher, T. (2004), 'What we touch, touches us: Materials, affects, and affordances', *Design Issues*, 20 (4): 20–31.

Franke, N. and Shah, S. (2003), 'How communities support innovative activities: an exploration of assistance and sharing among end-users', *Research Policy*, 32: 157–78.

Freeman, J. (2004), *The Making of the Modern Kitchen: Gender, Design and Culture in the Twentieth Century*, Oxford: Berg.

Friedel, R. (1983), *Pioneer Plastics: The Making and Selling of Celluloid*, Wisconsin, Maddison: University of Wisconsin Press.

Fulton Suri, J. (2003), 'The Experience of Evolution: Developments in Design Practice', *Design Journal*, 6 (2): 39–48.

Geels, F. and Smit, W. (2000), 'Failed Technology Futures: Pitfalls and lessons from a historical survey', *Futures*, 32 (9): 867–85.

Gelber, S. (1997), 'Do-It-Yourself: Constructing, Repairing and Maintaining Domestic Masculinity', *American Quarterly*, 49 (1): 66–112.

Gell, A. (1986), 'Newcomers to the world of goods: consumption among the Muria Gonds' in A. Appadurai (ed.), *The Social Life of Things*, Cambridge: Cambridge University Press.

Giddens, A. (1984), *The Constitution of Society*, Cambridge: Polity Press.

Goldberg, M. (1995), *Collectible Plastic Kitchenware and Dinnerware 1935–1964*, Atglen, PA: Schiffer Publishing Ltd.

Good Housekeeping (2002), *Good Housekeeping*, January.

Graeber, D. (1996), 'Beads and Money: Notes toward a Theory of Wealth and Power', *American Ethnologist*, 23 (1): 4–24.

Graeber, D. (2001), *Toward an Anthropological Theory of Value: The False Coin of Our Own Dreams*, New York: Palgrave.

Grinter, R. (2005), 'Words about images: Coordinating Community in Amateur Photography', *Computer Supported Cooperative Work*, 14 (2): 161–88.

Gronow, J. and Warde, A. (2001), *Ordinary Consumption*, Reading: Harwood.

Grzecznowska, A. (2005), 'Design impact on the economic output of enterprises and their competitive position' presented at the Design Research, Industries and a New Interface for Competitiveness Conference, 22–4 September, University of Art and Design, Helsinki.

Hand, M. and Shove, E. (2004), 'Orchestrating concepts: kitchen dynamics and regime change in *Good Housekeeping* and *Ideal Home* 1922–2002', *Journal of Home Cultures*, 1 (3): 235–57.

Hand, M. and Shove, E. (2007), 'Condensing practices: ways of living with a freezer', *Journal of Consumer Culture*, 7(1): 79–104.

Handley, S. (1999), *Nylon: The Manmade Fashion Revolution*, London: Bloomsbury.

Handy Jam Organization (1945), *The Kingdom of Plastics*, from www.archive. org/details/Kingdomo1945

Hannington, B. (2003), 'Methods in the Making: A Perspective on the State of Human Research in Design', *Design Issues*, 19 (4): 9–18.

Haraway, D. (1991), *Siminans, Cyborgs and Women: The Reinvention of Nature*, London: Free Association Books.

Harrison, B. (2004), 'Snap Happy: Toward a Sociology of Everyday Photography', in C. Pole (ed.), *Seeing is Believing? Approaches to Visual Research*, Oxford: Elsevier: 23–40.

Heskett, J. (2002), *Toothpicks and Logos: Design in Everyday Life*, Oxford: Oxford University Press.

Hill, D. (2004), 'Adaptation, personalization and "self-centred" design', in N. Wakeford (ed.), *Innovation Through People-centred Design – Lessons from the USA*, London: DTI Global Watch Mission Report.

Hirsch, J. (1981), *Family Photographs: Content, Meaning and Effect*, Oxford: Oxford University Press.

Holt, D. (1997), 'Distinction in America? Recovering Bourdieu's Theory of Taste from its Critics', *Poetics*, 25: 93–120.

Ideal Home (1956a), 'Bex houseware', *Ideal Home*, March: 144.

Ideal Home (1956b), 'Ekco advertisement', *Ideal Home*, February: 32.

Ideal Home (1956c), 'Bex housewares advertisement', *Ideal Home*, June: 19.

Ideal Home (1957a), 'Alkathene advertisement', *Ideal Home*, May: 118.

Ideal Home (1957b), 'Addis advertisement', *Ideal Home*, June: 18.

Ideal Home (1959), 'Decorplast advertisement', *Ideal Home*, February: 92.

Ideal Home (1962), 'Melmex advertisement', *Ideal Home*, June: 150.

Illmonen, K. (2004), 'The use of and commitment to goods', *Journal of Consumer Culture*, 4 (1): 27–50.

Jalas, M. (2006), *Busy, Wise and Idle Time. A Study of the Temporalities of Consumption in the Environmental Debate*, Helsinki: Helsinki School of Economics Print.

Johnson, L. and Lloyd, J. (2004), *Sentenced to Everyday Life – Feminism and the Housewife*, Oxford: Berg.

Julier, G. (2000), *The Culture of Design*, London: Sage.

Katz, S. (1978), *Plastics: Designs and Materials*, London: Studio Vista.

Kaufmann, J-C. (1998), *Dirty Linen: Couples and their Laundry*, Middlesex: Middlesex University Press.

Keat, R. and Abercrombie, N. (eds) (1991), *Enterprise Culture*, London: Routledge.

Kelley, T. and Littman, J. (2001), *The Art of Innovation: Lessons in Creativity from IDEO, America's Leading Design Firm*, New York: Currency/Doubleday.

Kelley, T. and Littman, J. (2005), *The Ten Faces of Innovation*, New York: Doubleday.

Kember, S. (1998), *Virtual Anxiety: Photography, New Technologies and Subjectivity*, London: Routledge.

Kemp, R., Schot, J. and Hoogma, R. (1998), 'Regime Shifts to Sustainability Through Processes of Niche Formation: The Approach of Strategic Niche Management', *Technology Analysis and Strategic Management*, 10: 175–95.

Keynote (2003), 'Small Domestic Electrical Appliances': Market Research Report.

King, G. (1986), *Say 'Cheese': The Snapshot as Art and Social History*, London: Collins.

Kingfisher (2006), Preliminary results for the 52 weeks ended 28 January 2006. London: Kingfisher plc, from http://www.kingfisher.co.uk/files/english/reports/prelim06.pdf 29 March 2006

Kissell, J. (2005), *House of the Future. Disneyland's 1957 All-plastic House*, from http://itotd.com/articles/538/house-of-the-future

Korkman, O. (2006), 'Customer Value Formation in Practice. A Practice-Theoretical Approach', *Department of Marketing and Corporate Geography*, Helsinki: Swedish School of Economics and Business Administration.

Krippendorff, K. and Butler, R. (1984), 'Product Semantics: Exploring the Symbolic Qualities of Form', *Innovation*, 3 (2): 4–9.

Kuniavsky, M. (2003), *Observing the User Experience. A Practitioner's Guide to User Research*, San Francisco: Morgan Kaufman.

Lash, S. (2002), *Critique of Information*, London: Sage.

Latour, B. (1987), *Science in Action: How to Follow Scientists and Engineers through Society*, Cambridge, MA: Harvard University Press.

Latour, B. (1991), 'Technology is Society Made Durable', in J. Law (ed.), *A Sociology of Monsters: Essays on Power, Technology and Domination*, London: Routledge: 103–31.

Latour, B. (1992), 'Where are the Missing Masses? A Sociology of a Few Mundane Artifacts', in W. Bijker and J. Law (eds), *Shaping Technology/Building Society*, Cambridge Mass: MIT Press: 225–58.

Latour, B. (1993), *We Have Never Been Modern*, Hemel Hempstead: Harvester Wheatsheaf.

Latour, B. (1999), *Pandora's Hope. Essays on the Reality of Science Studies*, London: Harvard University Press.

Latour, B. (2000), 'When things strike back: a possible contribution of "science studies" to the social sciences', *British Journal of Sociology*, 51 (1): 107–23.

Leadbeater, C. and Miller, P. (2004), *The Pro-Am Revolution*, London: Demos.

Liddle, D. (1995), 'Connecting Value', Keynote Address, *7th International Forum on Design Management Research and Education*. Stanford University.

Lister, M. (2001), 'Photography in the Age of Electronic Imaging', in L. Wells (ed.), *Photography: A Critical Introduction*, London: Routledge: 303–47.

Littlewood, A. and Munro, M. (1996), 'Explaining disrepair: Examining owner occupiers' repair and maintenance behaviour', *Housing Studies*, 11 (4): 503–25.

Lunenfeld, P. (2000), *Snap to Grid*, Cambridge, MA: MIT Press.

Lury, C. (1996), *Consumer Culture*, Cambridge: Polity Press.

Lury, C. (1998), *Prosthetic Culture: Photography, Memory and Identity*, London and New York: Routledge.

Madigan, R. and Munro, M. (1996), 'House Beautiful: Style and Consumption in the Home', *Sociology*, 30 (1): 41–57.

Manzini, E. (1992), 'Plastics and the challenge of quality', from http://www.changedesign.org/Resources/Manzini/Manuscripts/Plastics and the Challenge of Quality.pdf

Mauss, M. (1950 [1990]), *The Gift: The Form and Reason for Exchange in Archaic Societies*, London: Routledge.

McCracken, G. (1988), *Culture and Consumption: New Approaches to the Symbolic Character of Consumer Goods and Activities*, Bloomington: Indiana University Press.

McCracken, G. (2005), *Culture and Consumption 2: Markets, Meaning and Brand Management*, Bloomington: Indiana University Press.

Meikle, J. (1979), *20th Century Limited: Industrial Design in American 1925–1939*, Philadelphia: Temple University Press.

Meikle, J. (1993), 'Decorative Laminates', *The Plastiquarian*, Spring: 11.

Meikle, J. (1997), *American Plastic: A Cultural History*, New Brunswick: Rutgers University Press.

Merriman, T. (1991), 'Quiet Revolution', *The Plastiquarian*, 7: 13.

Michael, M. (2000), *Reconnecting Culture, Technology and Nature: From Society to Heterogeneity*, London: Routledge.

Miller, D. (1997), 'Consumption and its consequences' in H. Mackay (ed.), *Consumption and Everyday Life*, London: Sage and the Open University: 13–64.

Miller, D. (1998a), 'Coca-Cola: A Black Sweet Drink from Trinidad', in D. Miller (ed.), *Material Cultures: Why Some Things Matter*, London: UCL Press: 167–89.

Miller, D. (1998b), *Material Cultures: Why Some Things Matter*, London: UCL Press.

Miller, D. (ed.) (2001), *Home Possessions*, Oxford: Berg.

Miller, L. (1995), 'Family Togetherness and The Suburban Ideal', *Sociological Forum*, 10 (3): 393–418.

Mintel (2001), UK Domestic Appliances: Market Research Report.

Mintel (2003), DIY Review 2003: Mintel International Group Ltd.

Mintel (2005), DIY Review 2005: Mintel International Group Ltd.

Mitchell, W. (1992), *The Reconfigured Eye: Visual Truth in the Post Photographic Era*, Cambridge, MA: MIT Press.

Molotch, H. (2003), *Where Stuff Comes From: How Toasters, Toilets, Cars, Computers and Many Other Things Come to Be as They Are*, London and Philadelphia: Taylor and Francis.

Nelson, M. (2004), 'How men matter: Housework and self-provisioning among rural single-mother and married-couple families in Vermont, US', *Feminist Economics*, 10 (2): 9–36.

Nickles, S. (2002), 'Preserving Women: Refrigerator Design as Social Process in the 1930s', *Technology & Culture*, 43: 693–727.

Norman, D. (2004), *Emotional Design: Why We Love (or Hate) Everyday Things*, New York: Basic Books.

ONS (2001a), 'General Household Survey', London: The Office for National Statistics, UK.

ONS (2001b), *Household Satellite Survey 2000*, from http://www.statistics.gov.uk/hhsa.

Overbeeke, C., Djadjadiningrat, J., Wensveen, S. and Hummels, C. (2002), 'Beauty in Usability: forget about ease of use!' in P. Jordan and W. Green (eds), *Pleasure with Products: Beyond Usability*, London and Philadelphia: Taylor and Francis: 9–19.

Pantzar, M. (2003), 'Tools or Toys: inventing the need for domestic appliances in postwar and postmodern Finland', *Journal of Advertising*, 32 (1): 81–91.

Pantzar, M. and Sundell-Nieminen, R. (2003), 'Towards an Ecology of Goods: symbiosis and competition between household goods' in I. Koskinen (ed.), *Empathetic Design: User Experience in Product Design*, Helsinki: IT Press.

Papanek, V. (1995), *The Green Imperative*, London: Thames and Hudson.

Parr, J. (1999), *Domestic Goods: The Material, the Moral, and the Economic in the Postwar Years*, Toronto: University of Toronto Press.

Patrucco, P. (2005), 'The Emergence of Technology Systems: knowledge, production and distribution in the case of the Emilian plastics district', *Cambridge Journal of Economics*, 29 (1): 37–56.

Plastiquarian (2005), 'Albert Henry Woodfull', *The Plastiquarian*, Summer (34).

Pollakowski, H.O. (1988), 'The Determinants of Residential Renovation and Repair Activity', Final Report Prepared for the Office of Policy Development and Research, Washington DC: US Department of Housing and Urban Development.

Preda, A. (1999), 'The Turn to Things: Arguments for a sociological theory of things', *Sociological Quarterly*, 40: 347–66.

Reckwitz, A. (2002), 'Towards a Theory of Social Practices: A development in culturalist theorizing', *European Journal of Social Theory*, 5 (2): 243–63.

Redström, J. (2006), 'Towards user design? On the shift from object to user as the subject of design', *Design Studies*, 27: 123–39.

Rip, A. (2005), 'A sociology and political economy of scientific-technological expectations', *UNICES Seminar*, Utrecht.

Rip, A., Oudschoorn, N. and Tauritz Bakker, L. (2006), 'Material Narratives of Technology in Society', presented at the Twente workshop on Material Narratives of Technology in Society, 19–21 October 2006, Enschede, The Netherlands.

Rip, A. and Van Lente, H. (1998), 'Expectations in Technological Developments: An example of prospective structures to be filled in by agency' in C. Disco and B. van der Meulen (eds), *Getting New Technologies Together: Studies in Making Sociotechnical Order*, Berlin: de Gruyter: 203–230.

Roush, C. (1999), *Inside Home Depot: How One Company Revolutionized an Industry through the Relentless Pursuit of Growth*, New York: McGraw Hill.

Schatzberg, E. (2003), 'Symbolic Culture and Technological Change: The cultural history of aluminium as an industrial material', *Enterprise & Society*, 4 (June): 226–71.

Schatzki, T. (1996), *Social Practices: A Wittgensteinian Approach to Human Activity and the Social*, Cambridge: Cambridge University Press.

Schatzki, T. (ed.) (2001), *The Practice Turn in Contemporary Theory*, London: Routledge.

Schatzki, T. (2002), *The Site of the Social*, Pennsylvania: Pennsylvania University Press.

Schneider, J. (1994), 'In and Out of Polyester: Desire, Distain and Global Fibre Competitions', *Anthropology Today*, 10 (4): 2–10.

Schulz, J. (2006), 'Vehicle of the Self: The social and cultural work of the H2 Hummer', *Journal of Consumer Culture*, 6 (1): 57–86.

Seymour Powell (nd), *emotional ergonomics*, from www.seymourpowell.com/ideas/ergonomics.html

Shove, E. (2003), *Comfort, Cleanliness and Convenience: The Social Organisation of Normality*, Oxford: Berg.

Shove, E. and Pantzar, M. (2005), 'Consumers, producers and practices: understanding the invention and reinvention of Nordic Walking', *Journal of Consumer Culture*, 5 (1): 43–64.

Shove, E. and Pantzar, M. (2006), 'Fossilisation', *Ethnologia Europaea, Journal of European Ethnology*, 356 (1–2): 59–63.

Shove, E. and Southerton, D. (2000), 'Defrosting the freezer: From novelty to convenience – A narrative of normalization', *Journal of Material Culture*, 5 (3): 301–19.

Silverstone, R. (1993), 'Time, information and communication technologies in the household', *Time and Society*, 2 (3): 283–311.

Silverstone, R. and Haddon, L. (1996), 'Design and the Domestication of Information and Communication Technologies: Technical Change and Everyday Life', in R. Mansell and R. Silverstone (eds), *Communication by Design: The Politics of Information and Communication Technologies*, Oxford: Oxford University Press: 44–74.

Silverstone, R. and Hirsch, E. (eds) (1992), *Consuming Technologies*, London: Routledge.

Silverstone, R., Hirsch, E. and Morley, D. (1992), 'Information and communication technologies and the moral economy of the household', in Silverstone, R. and Hirsch, E. (eds), *Consuming Technologies*, London: Routledge: pp. 15–31.

Singleton, W. (1974), *Man-Machine Systems*, Harmondsworth: Penguin.

Slater, D. (1991), 'Consuming Kodak', in J. Spence and P. Holland (eds), *Family Snaps: The Meaning of Domestic Photography*, London: Virago: 49–59.

Slater, D. (1995), 'Domestic photography and digital culture', in M. Lister (ed.), *The Photographic Image in Digital Culture*, London: Routledge.

Slater, D. (1997), *Consumer Culture and Modernity*, Cambridge: Polity Press.

Sontag, S. (1979), *On Photography*, Harmondsworth: Penguin.

Southerton, D. (2001), 'Consuming Kitchens', *Journal of Consumer Culture*, 1 (2): 179–203.

Sparke, P. (1983), *Consultant Design: The History and Practice of the Designer in Industry*, London: Pembridge Press.

Sparke, P. (1987), *Design in Context: History, Application and Development of Design*, London: Bloomsbury.

Sparke, P. (ed.) (1990), *The Plastics Age*, London: V&A Museum.

Sparke, P. (1995), *As Long as it is Pink: The Sexual Politics of Taste*, London: Pandora.

Spence, J. and Holland, P. (eds) (1991), *Family Snaps: The Meaning of Domestic Photography*, London: Virago.

Streb, J. (2003), 'Shaping the national system of inter-industry knowledge exchange: vertical integration, licensing and repeated knowledge transfer in the German plastics industry', *Research Policy*, 32: 1125–40.

Suchman, L., Blomberg, J., Orr, J. and Trigg, R. (1999), 'Reconstructing Technologies as Social Practice', *American Behavioural Scientist*, 43 (3): 392–408.

Sullivan, O. and Gershuny, J. (2004), 'Inconspicuous Consumption: Work-Rich, Time-Poor in the Liberal Market Economy', *Journal of Consumer Culture*, 4 (1): 79–100.

Thackara, J. (2005), *In the Bubble, Designing for a Complex World*, Cambridge, MA: MIT Press.

Tharp, B. (2002), 'Value: Conceptions in Industrial Design and Anthropology', Vogel's and Cagan's *Creating Breakthrough Products* meets Graeber's *Toward an Anthropological Theory of Value*, IDSA 2002 National Education Conference, San Jose, from http://new.idsa.org/webmodules/articles/articlefiles/ed.conference02/42.pdf

Thrift, N. (2006), 'Re-inventing invention: new tendencies in capitalist commodification', *Economy and Society*, 35 (2): 276–306.

Trigger, B. (1989), *A History of Archaeological Thought*, Cambridge: Cambridge University Press.

Van Kenhove, P., De Wulf, K. and Van Waterschoot, W. (1999), 'The impact of task definition on store-attribute saliences and store choice', *Journal of Retailing*, 75 (1): 125–37.

Vardin Sales Corp (1956), *Aztec Breakproof Melmac Dinnerware*, from www.plasticliving.com/brochures/aztec.jpg

Veblen, T.B. (1912 [1899]), *The Theory of the Leisure Class: An Economic Study of Institutions*, New York: Macmillan.

Wakeford, N. (ed.) (2004), *Innovation Through People-centred Design – Lessons from the USA*, London: DTI Global Watch Mission Report.

Warde, A. (2005), 'Consumption and Theories of Practice', *Journal of Consumer Culture*, 5 (2): 131–53.

Webster, F. (ed.) (2004), *The Information Society Reader*, London: Routledge.

Williams, C. (2004), 'A lifestyle choice? Evaluating the motives of do-it-yourself (DIY) consumers', *International Journal of Retail and Distribution Management*, 32 (5): 270–8.

Woodhouse, E. and Patton, J. (2004), 'Design by Society: Science and Technology Studies and the Social Shaping of Design', *Design Issues*, 20 (3): 1–12.

Woodward, I. (2003), 'Divergent narratives in the imagining of the home amongst middle-class consumers – Aesthetics, comfort and the symbolic boundaries of self and home', *Journal of Sociology*, 39 (4): 391–412.

Woolgar, S. (1991), 'Configuring the User: The Case of Usability Trials' in J. Law (ed.), *A Sociology of Monsters: Essays on Power, Technology and Domination*, London: Routledge.

Yarsley, V.E. and Couzens, E.G. (1941), *Plastics*, Harmondsworth: Pelican.

Yarsley, V.E. and Couzens, E.G. (1943), *Plastics in the Home*, London: J.M. Dent.

Yesterland (2006), *Monsanto House of the Future*, 21 September 2006, from www.yesterland.com/futurehouse.html

Young, D. (2004), 'The Material Value of Color: the Estate Agent's Tale', *Home Cultures*, 1 (1): 5–22.

Zerubavel, E. (1985), *Hidden Rhythms*, Berkeley: University of California Press.

Index